Georgia

O'Keeffe

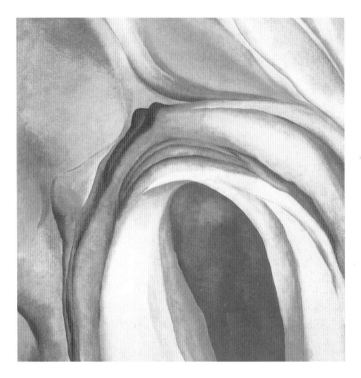

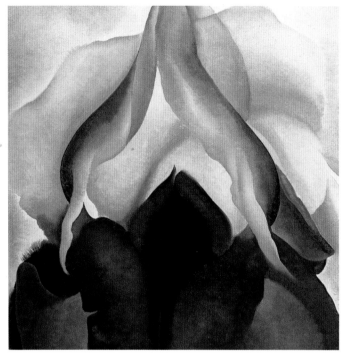

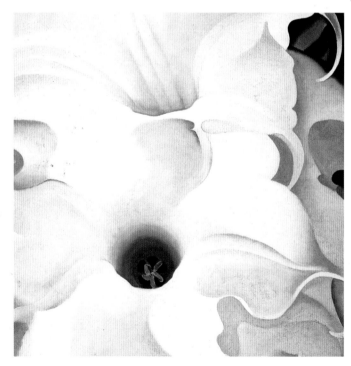

© 2005 Sirrocco, London, UK (English version)
© 2005 Confidential Concepts, worldwide, USA
© 2005 Estate O'Keeffe / Artists Rights Society, New York, USA

ISBN 1-84013-769-X

Published in 2005 by Grange Books
an imprint of Grange Book Plc
The Grange Kingsnorth Industrial Estate
Hoo, nr Rochester, Kent ME3 9ND
www.Grangebooks.co.uk

Printed in China

Georgia O'Keeffe

Grange BOOKS

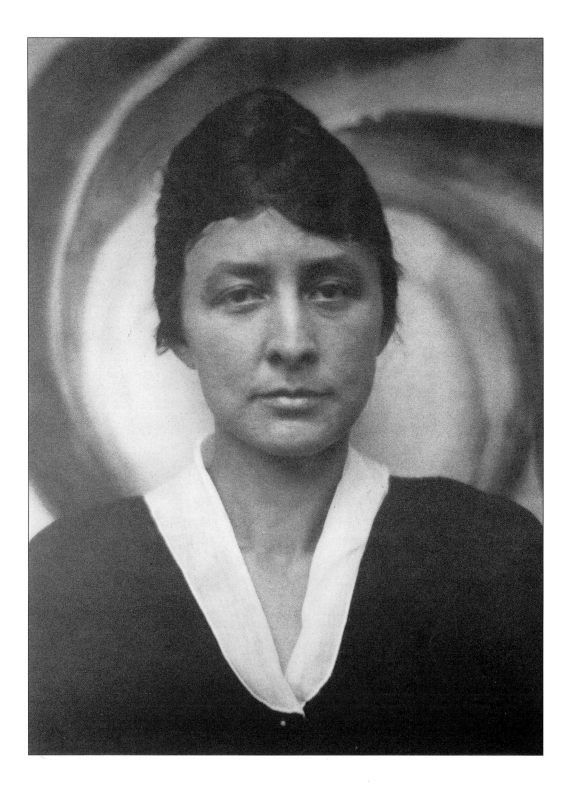

Georgia O'Keeffe, in her ability to see and marvel at the tiniest detail of a flower or the vastness of the southwestern landscape, drew us in as well. The more she cultivated her isolation, the more she attracted the rest of the world. What is it that makes her legacy so powerful, even today? People recognize flowers, bones, buildings. But something in her paintings also shows us how to see. We stroll on the beach or hike a footpath and barely notice a delicate seashell or the subtle shades of a pebble; we kick aside a worn shingle. Driving through the desert we shade our eyes from the sun, blink, and miss the lone skull, signifying a life long since gone. Georgia embraced all these things and more, brought them into focus and forced us to make their acquaintance. Then she placed them in a context that stimulated our imagination. The remains of an elk's skull hovering over the desert's horizon, or the moon looking down on the hard line of a New York skyscraper briefly guide us into another world.

In her own life she showed women that it was possible to search out and find the best in themselves; easier today, not so easy when Georgia was young. Her later years serve as a role model for those of us who feel life is a downhill slide after the age of sixty. Well into her nineties, her eyesight failing, she still found ways to express what she saw and how it excited her.

To this day, her work is as bright, fresh and moving as it was nearly 100 years ago. Why? Because the paintings, although simple in their execution, hold a feeling of order, of being well thought out, a steadiness, yet also serve as a vehicle to help all of us see and examine the sensual delicacy of a flower, the starkness of a bleached skull and the electricity of a Western sunset.

Georgia Totto O'Keeffe was born on November 15, 1887 on a farm near the village of Sun Prairie, Wisconsin, the first daughter and second child of Francis and Ida Totto O'Keeffe. Georgia's childhood was singularly uneventful. She spent her early and middle years in the large family home near Sun Prairie, an area of rolling hills and farmland.

In the evenings and on rainy days, mother Ida O'Keeffe, believing in the importance of education, read to her children from books such as James Fenimore Cooper's *Leatherstocking Tales* or stories of the west. Ida had spent much of her childhood on a farm next to the O'Keeffe property. When her father, George, left the family to return to his native Hungary, Ida's mother Isabel, moved the children to Madison, Wisconsin where her children might have the opportunity for a formal education.

1. *Portrait of Georgia O'Keeffe*

2. *Blue Lines, N° 10,* 1916. Watercolor, 63.5 x 48.3 cm. Metropolitan Museum of Art, New York.

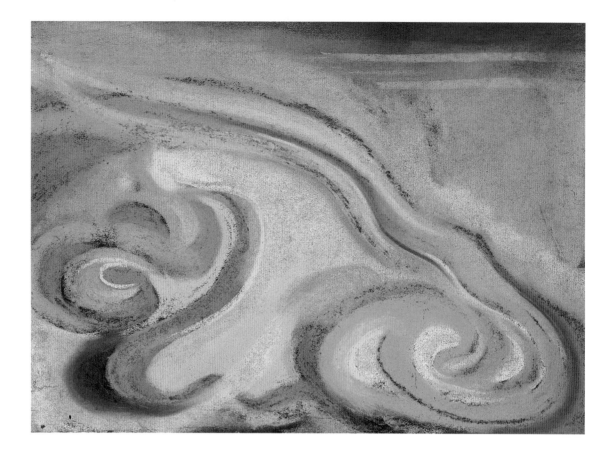

3. *Special N° 32*, 1914.
Pastel on paper,
35.5 x 49.5 cm.
Private collection.

4. *Abstraction*, 1916,
1979-1980. White
lacquered bronze,
25.7 x 12.7 x 12 cm.
Georgia O'Keeffe
Museum, Santa Fe.

Ida enjoyed pursuing her intellectual interests, and as a young girl thought of becoming a doctor. But when she reached her late teens, Francis O'Keeffe, who remembered her as the attractive girl from the nearby farm, visited her regularly in Madison and eventually proposed marriage. For the next several years there was hardly a time when Ida was not pregnant or nursing. She was a farmer's wife whose education had been cut short. She wanted more for her offspring and over the next several years clung to the belief that if her children had the advantage of an exposure to culture, and a well-rounded education, it might keep them from falling further down the social ladder. She also felt it was important for her daughters to have the skills needed to earn their own living should the need arise.

For nine years, Georgia walked to the one-room Town Hall schoolhouse, a short distance from her home. Perhaps because of the importance her mother had placed on learning, the thin, dark-haired Georgia with the alert brown eyes was known to her neighbors and teachers as a bright, inquisitive little girl.

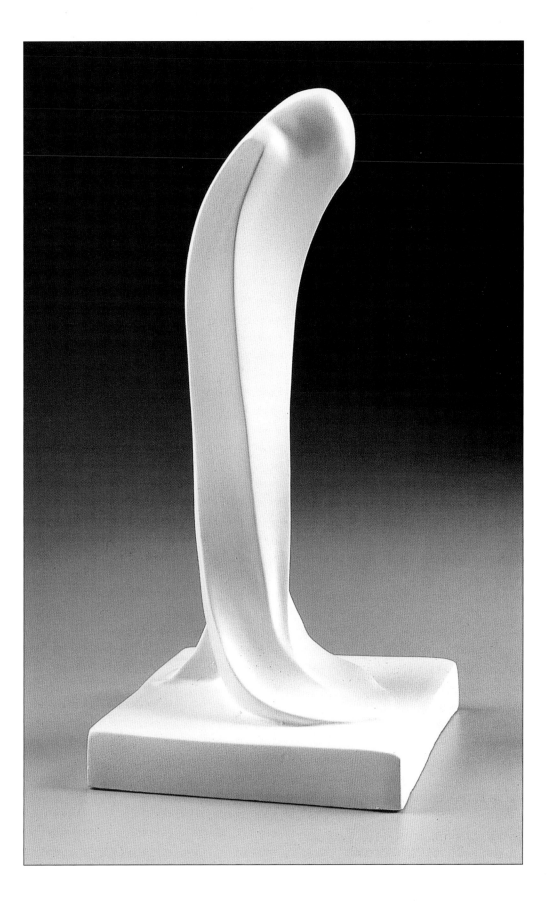

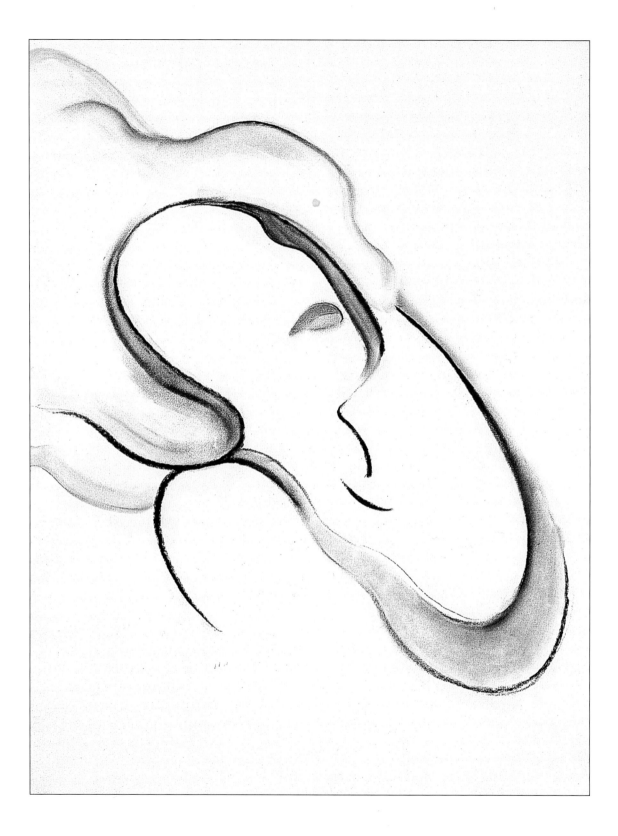

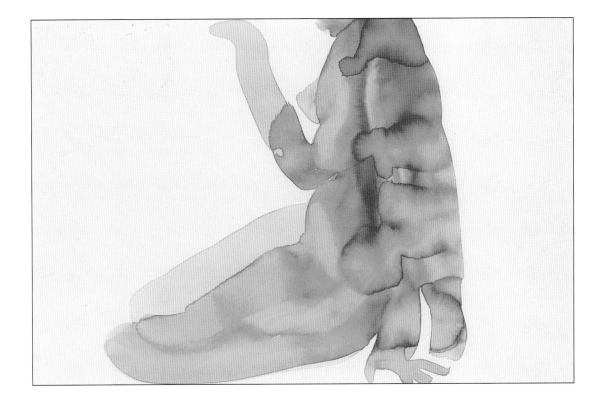

Consistent with her desire for her children to have as many educational advantages as possible, Ida enrolled her daughters in drawing and painting classes in Sun Prairie during their elementary school years. The following year they took painting classes on Saturdays and were allowed to choose a picture to copy. Georgia remembers just two – one of Paharoah's horses and another of large red roses. "It was the beginning with watercolor," she later wrote.

Georgia attended the one-room school up until eighth grade. Georgia remembers saying, "I'm going to be an artist." In the late nineteenth and early twentieth century few options were open to the woman seeking a career. She knew she could find work as a teacher, nurse, garment worker, governess, cook or housemaid. If she were ambitious or from an upper class family and could afford the education, the law and medical professions might let her in. As technology gained a foothold, she could be trained as a typist or telephone operator. In the world of art, a woman who attended a public art school went on to designing wallpaper, teaching, or commercial illustration. For most women, studying art was a stopgap pursuit to the ultimate goal – marriage.

5. *Abstraction IX*, 1916. Charcoal on paper, 61.5 x 47.5 cm. Metropolitan Museum of Art, New York.

6. *Nude Series XII*, 1917. Watercolor on paper, 30.5 x 45.7 cm. Georgia O'Keeffe Museum, Santa Fe.

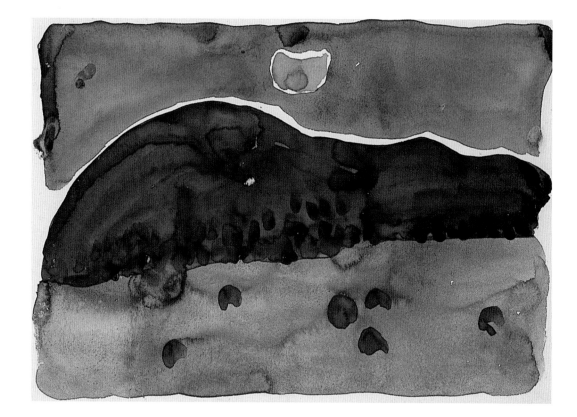

Georgia began her high school years at Sacred Heart Academy, a Dominican convent near Madison. For her second year, she and Francis Jr. were sent to Madison High School and lived with their aunt in town. The school's art teacher, a slight woman who wore a bonnet with artificial violets, gave Georgia her first insight into the mysteries and detail of the Jack-In-The-Pulpit flower. In her autobiography, O'Keeffe says:

> *"I had seen many Jacks before, but this was the first time I remember examining a flower… I was a little annoyed at being interested because I did not like the teacher… But maybe she started me looking at things – looking very carefully at details."*

7. *Evening,* 1916.
 Watercolor on paper,
 22.5 x 30.4 cm.
 Georgia O'Keeffe
 Museum, Santa Fe.

In 1902, Francis O'Keeffe moved his family to Williamsburg, Virginia. For Georgia, this meant changing schools once again and for the next two years, she attended Chatham Episcopal Institute, a boarding school two hundred miles away.

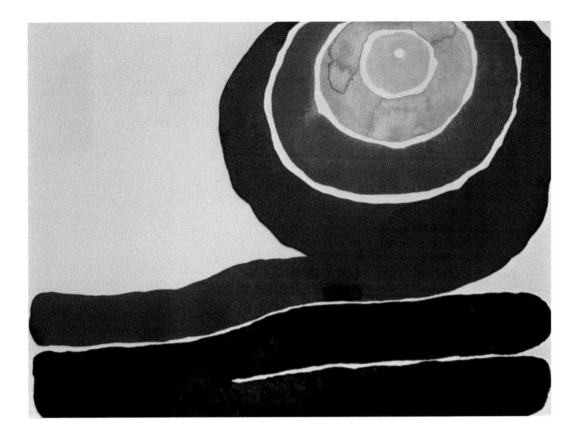

Georgia did not seem to mind the school's rules and rigid schedule imposed on her. Within her large family, she was the quiet child people tended to ignore, and relied on her own resources for amusement. At Chatham she enjoyed long walks in the woods, nurturing her love of nature, training her eye on a flower's intricate details, and letting her gaze wander to the Blue Ridge Mountains in the distance.

If there was one teacher in her adolescent years who had a profound influence on Georgia's life, it might have been Elizabeth May Willis, Chatham's principal and art instructor. Tuned into Georgia's inconsistent work habits, Willis let her student work at her own pace. One of the paintings that still exists is a still life called simply *Untitled (Grapes and Oranges)*, a watercolor in earth tones of rather dark green and ochre. The style is somewhat similar to the Impressionists, and shows her ability to work with color, light and shadow as well as displaying a mature drawing skill.

Her schoolwork suffered because of her indifference to studying and she barely graduated in June, 1905.

8. *Evening Star III*, 1917. Watercolor on paper, 22.8 x 30.5 cm. Museum of Modern Art, New York.

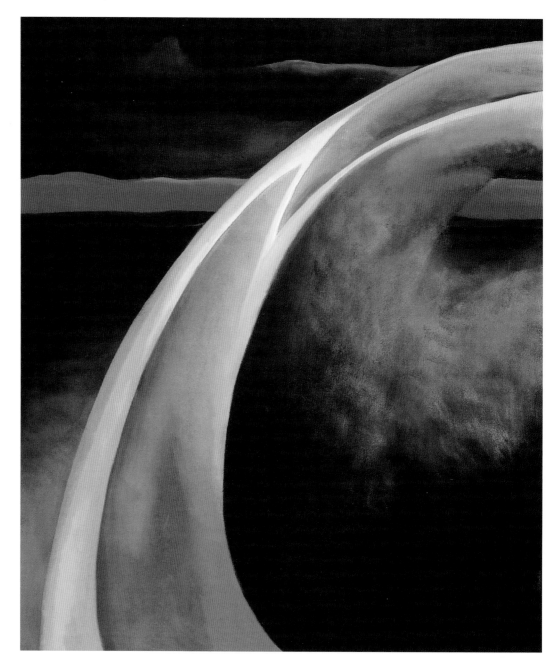

9. *Orange and Red
 Streak,* 1919.
 Oil on canvas,
 68.6 x 58.4 cm.
 Philadelphia Museum
 of Art, Philadelphia.

10. *Apple Family II,*
 1920. Oil on canvas,
 20.6 x 25.7 cm.
 Georgia O'Keeffe
 Museum, Santa Fe.

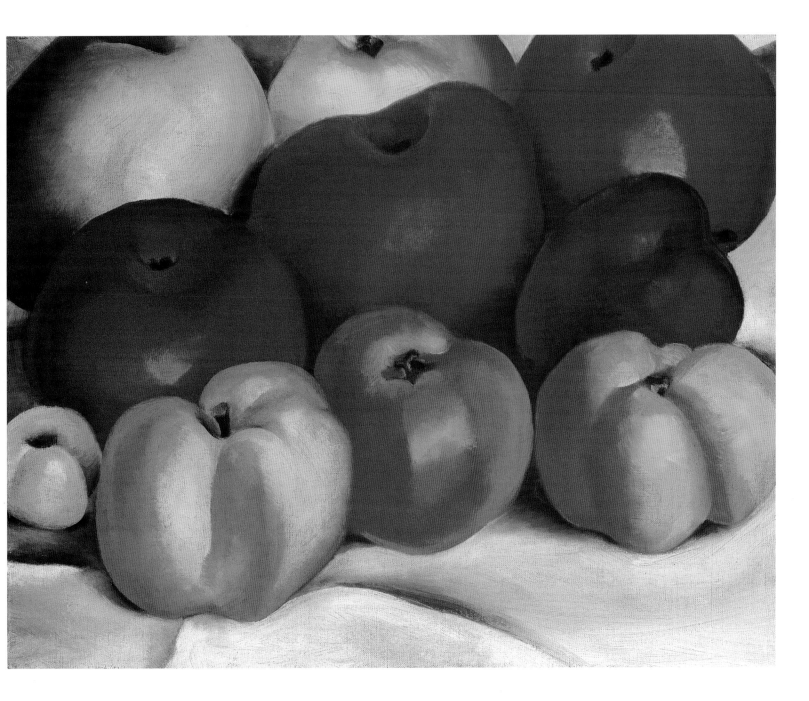

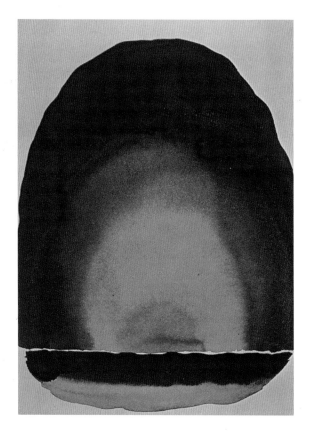

Following her graduation, and encouraged by her mother and Elizabeth Willis, Georgia began to pursue her art career in earnest and in 1905 returned to the Midwest to study at the School of the Art Institute of Chicago. At that time, it was unusual for girls to attend art school. Most Americans held fast to the Puritan ethic, and the idea of sending a daughter to an institution that employed nude models was considered a threat to her moral upbringing. But Georgia had family living in Chicago, so in a sense she was not unsupervised. One of the few remaining drawings she created at the time, entitled *My Auntie*, is of an aunt, Jennie Varnie. Even then one can see that she had confidence in her ability to capture the essence of a person. Shading and texture form the tired eyes, firm mouth and tilt of the head. There are no inhibitions, no struggle with drawing the perfect line, common to young serious art students.

The Art Institute and its environment were a marked change from the rolling green hills and heady fresh air of the country. Now she strolled along crowded streets and breathed air full of soot and smoke as she made her way to the imposing Art Institute entrance, flanked by the famous bronze lions.

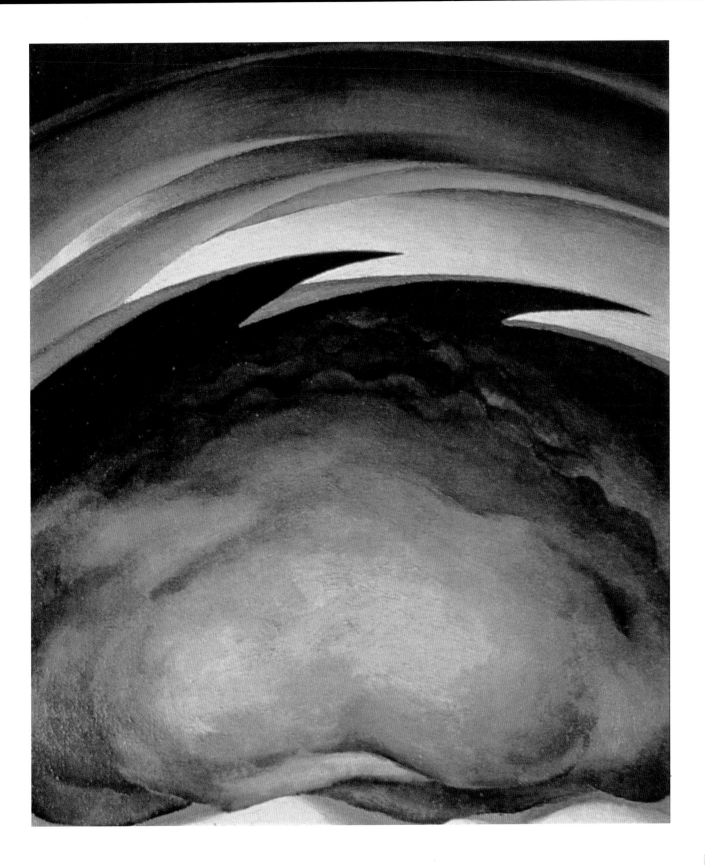

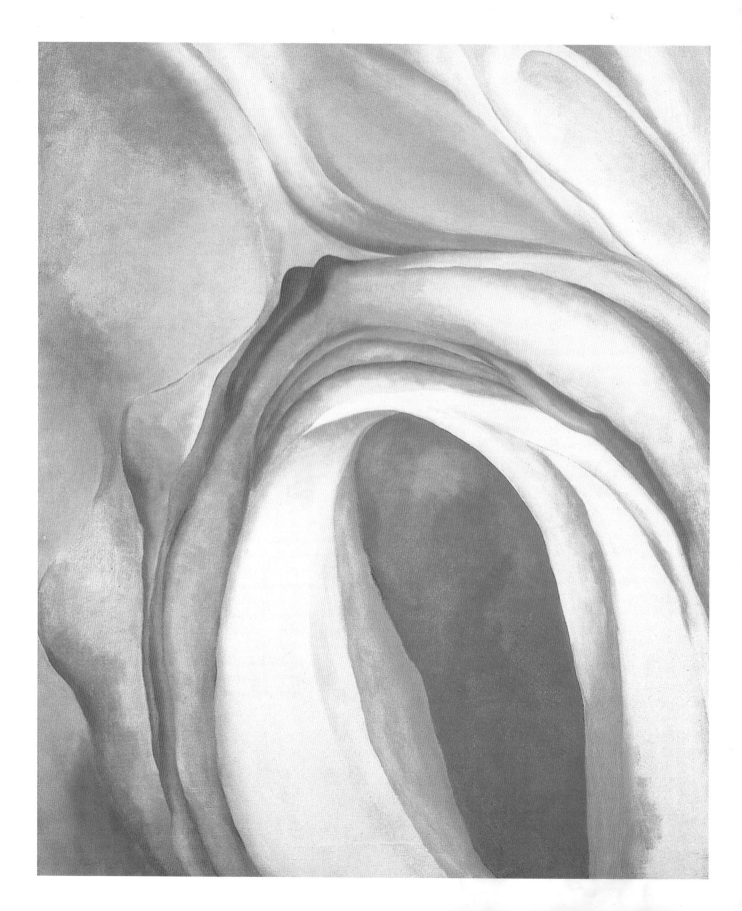

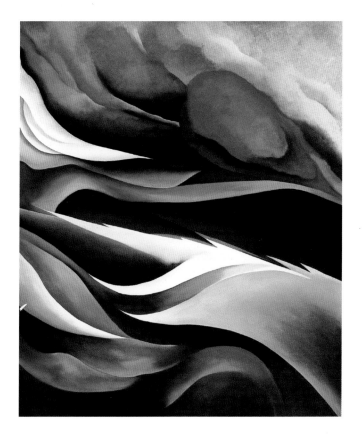

She was also now exposed, so to speak, to the human figure. The story has been told several times of her embarrassment at the sight of a male model appearing from behind the dressing room curtain wearing nothing more than a small loin cloth.

Although Georgia never had an interest in drawing or painting the human figure, she did hold in high regard her anatomy instructor John Vanderpoel, one of the few teachers whose skill in drawing had a profound influence on her for years to come. His book, *The Human Figure* was one she treasured throughout her career. At the end of the year, he gave Georgia's drawings the first place award, and her overall record was stated as "exceptionally high."

Georgia made plans to live in New York and attend the Art Students League School. The teeming city's atmosphere was in marked contrast to the country she loved so well, yet its vibrancy sparked her creativity, and she found herself among people with whom she could form lasting friendships. For a young woman like Georgia, who had not quite related to her surroundings anywhere else, it was like Dorothy opening the door to Oz.

13. *Music, Pink and Blue II*, 1919. Oil on canvas, 88.9 x 74 cm. Whitney Museum of American Art, New York.

14. *From the lake N° 1*, 1924. Oil on canvas, 94.3 x 78.7 cm. Des Moines Art Center, Iowa.

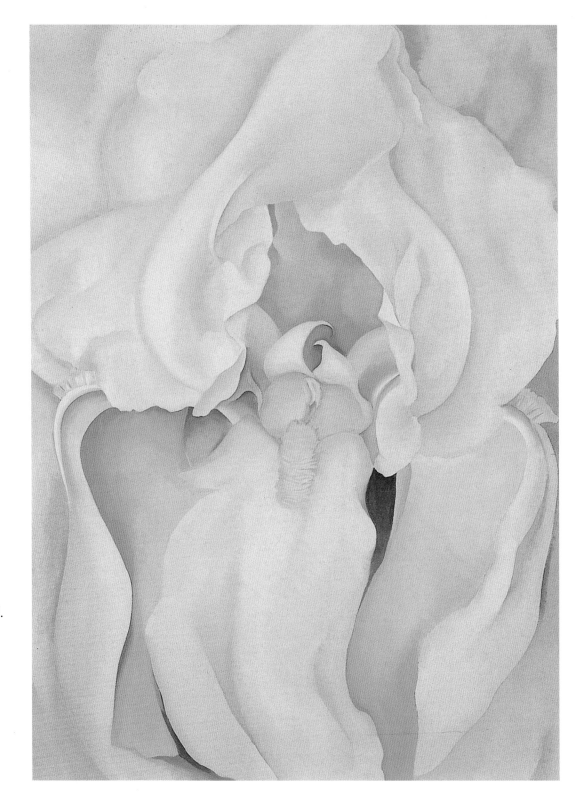

15. *Light Iris,* 1924.
Oil on canvas,
101.6 x 76.2 cm.
Virginia Museum of
Fine Arts, Richmond.

16. *Black Iris III,* 1926.
Oil on canvas,
91.4 x 75.9 cm.
Metropolitan
Museum of Art,
New York.

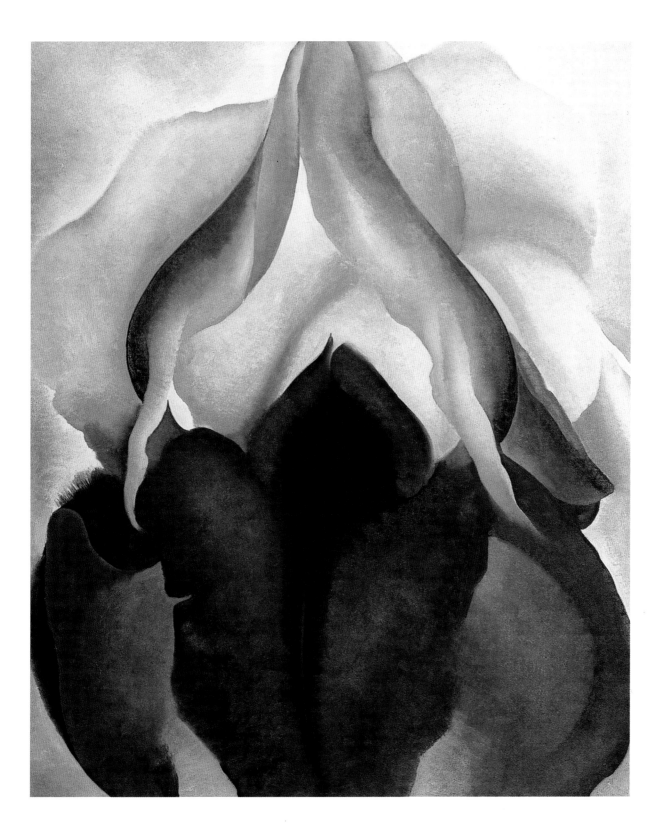

Georgia delighted in her still life classes with the dapper William Merritt Chase, one of many teachers who influenced her during that period. He imparted excitement to his students, and Georgia loved painting the gleaming brass and copper pots, shiny peppers, and textured onions that served as subject matter.

Just like her anatomy class at the School of the Art Institute, Georgia found the anatomy sessions conducted by Kenyon Cox singularly forgettable and his criticisms frightening. She remembers, however, fellow student Eugene Speicher who begged her to pose for him and once stopped her on the stairs, preventing her from passing until she agreed. When she replied that she only wanted to get to class, he made a prediction that he must have regretted often in the years to come. According to Georgia, he said, "It does not matter what you do... I'm going to be a great painter and you will probably end up teaching painting in some girls' school."

Although he let her go, she did finally let him paint her portrait, after, as she put it, "I went down the dark hall to the Life Class. The model happened to be a very repulsive man who gave me the creeps, so I gave up and went back to Speicher."

The following day she again posed for him and they were soon joined by others. After a short time, a student walked in and suggested they should all go over to see the Rodin drawings at the 291 Gallery. The gallery was owned by the well-known photographer and gallery-owner, supporter of avant-garde artists, Alfred Stieglitz. Stieglitz, a pioneer in the art of photography, had been the first to experiment and successfully produce photographs taken in inclement weather conditions – rain, snow and the dark of night. His exhibit of Rodin drawings marked a new path he had decided to take in giving exposure to avant-garde drawings and paintings.

While the exchanges between Stieglitz and the students became fierce and bordered on violence, Georgia stood in a corner to wait out the storm. At the time, she was not impressed with Rodin's watercolor washes supported by, as she described it, "curved lines and scratches." Years later when she went through Stieglitz's estate, those were the drawings she treasured the most.

Georgia finished her first year at the League with the $100 prize awarded to the top still-life artist, for her oil painting *Dead Rabbit with Copper Pot*. This resulted in an invitation to the League's summer school at Lake George, in upper New York State.

When Georgia returned to Williamsburg at the end of the summer, it was obvious to her that Francis O'Keeffe was in trouble.

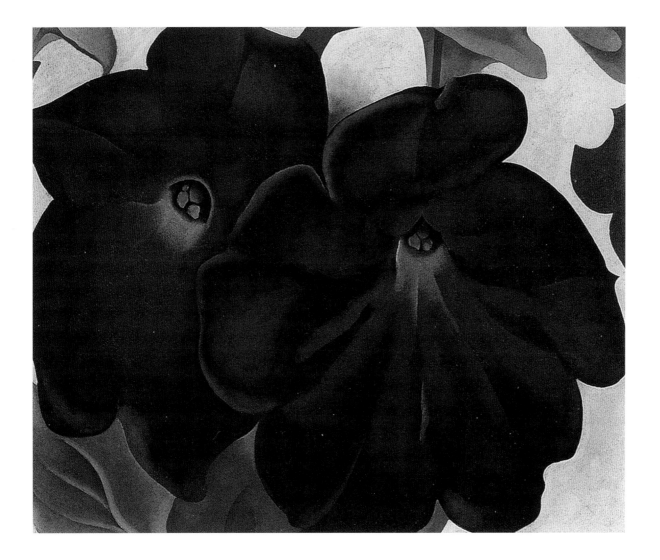

17. *Black and Purple
Petunias,* 1925.
Oil on canvas,
50.8 x 63.5 cm.
Private collection.

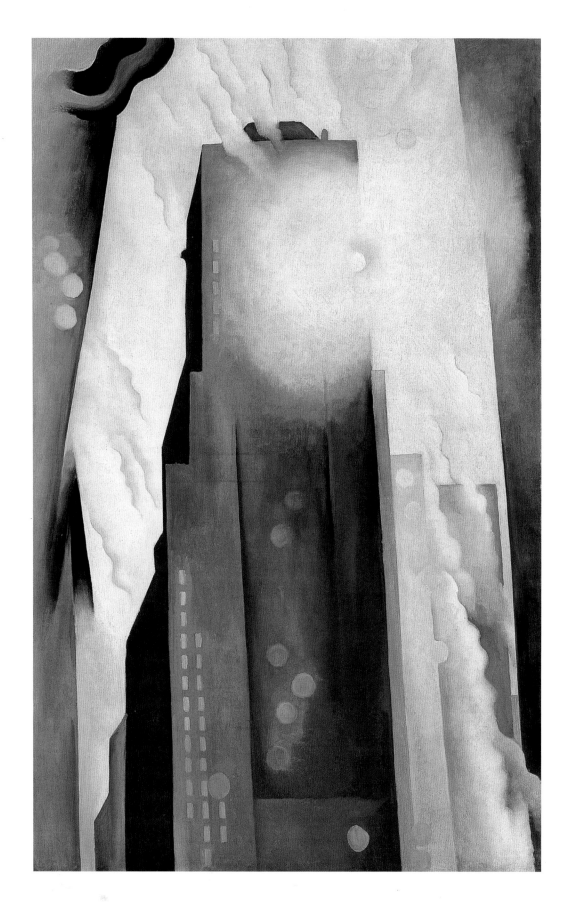

18. *The Shelton with
Sunspots,* 1926.
Oil on canvas,
123.2 x 76.8 cm.
The Art Institute of
Chicago, Chicago.

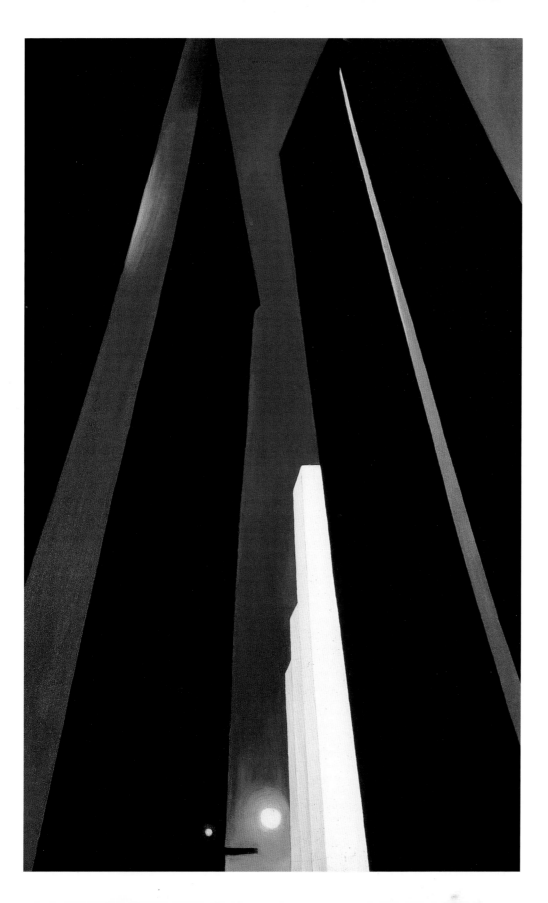

19. *City Night,* 1926.
Oil on canvas,
121.9 x 76.2 cm.
The Minneapolis
Institute of Arts,
Minneapolis.

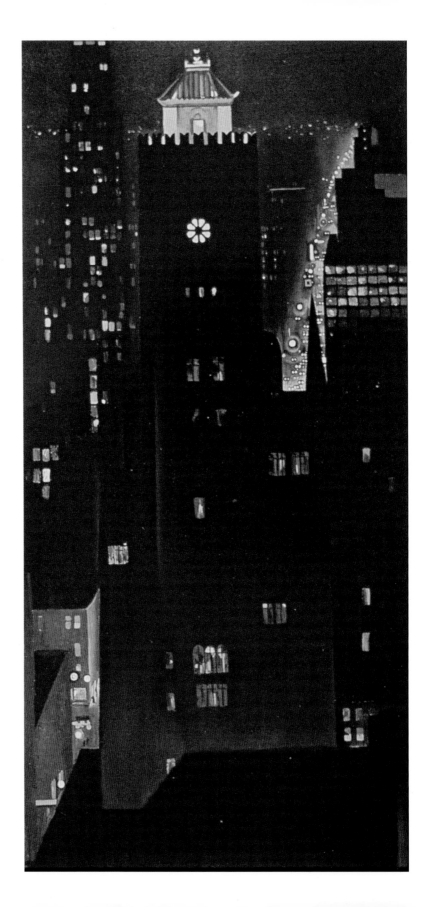

20. *New York, Night,*
 1928-1929.
 Oil on canvas,
 101.6 x 48.3 cm.
 Nebraska Art
 Association.

21. *Radiator Building,*
 Night, New York,
 1927.
 Oil on canvas,
 121.9 x 76.2 cm.
 Fisk University,
 Nashville.

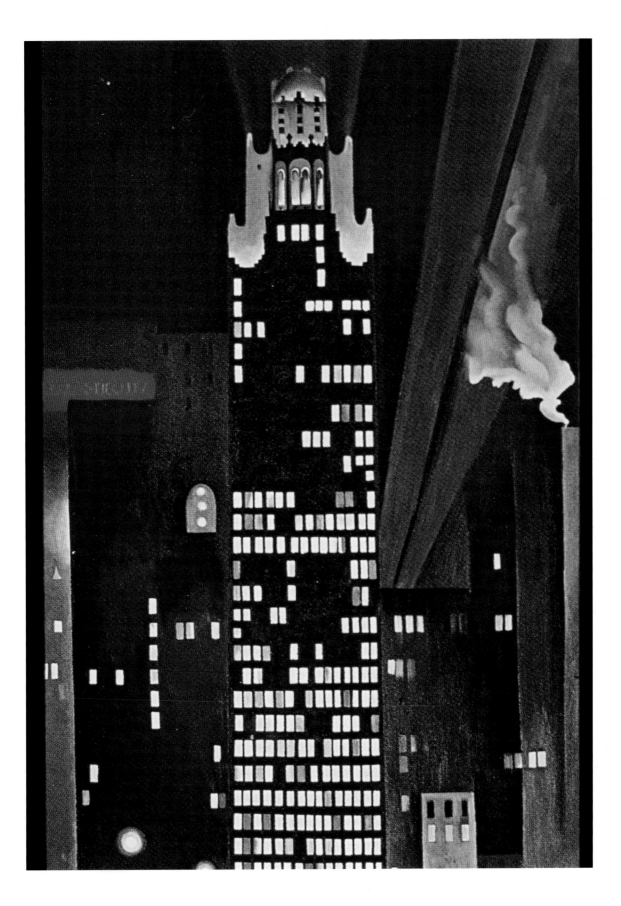

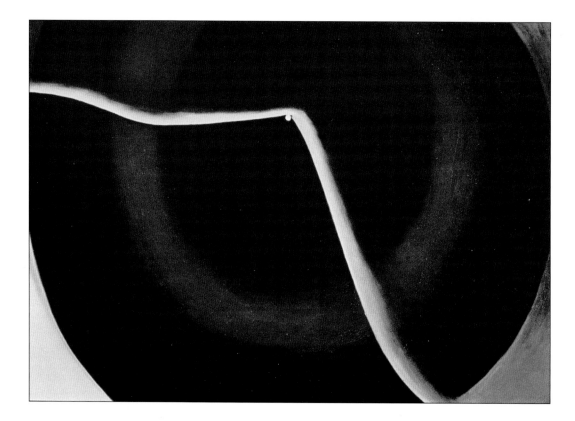

22. *Black Abstraction,*
 1927.
 Oil on canvas,
 76.2 x 102.2 cm.
 Metropolitan
 Museum of Art,
 New York.

23. *Red Hills and the*
 Sun, Lake George,
 1927.
 Oil on canvas,
 68.6 x 81.3 cm.
 Phillips collection,
 Washington.

Bad investments in building materials, coupled with real estate speculation and a creamery manufacturing business that never got off the ground, ate into the family's finances. She could see that there was no money for her to return to school at the League.

She could not go back to school, and marriage was out of the question for someone with Georgia's spirit and love of independence. The art fields open to a woman were fairly limited – she could work as an illustrator for newspaper and catalogue advertisements, teach, or attempt to build up a following with portraiture. In November of 1908, she left for Chicago to live once again with her mother's relatives. The advertising industry was growing and she found free-lance work illustrating lace and embroidery for dress advertisements. The meaningless repetitive work left her exhausted, bored and unhappy. She endured this life for two years, until she contracted measles. Her eyes weakened and, now unable to work, she returned to Williamsburg.

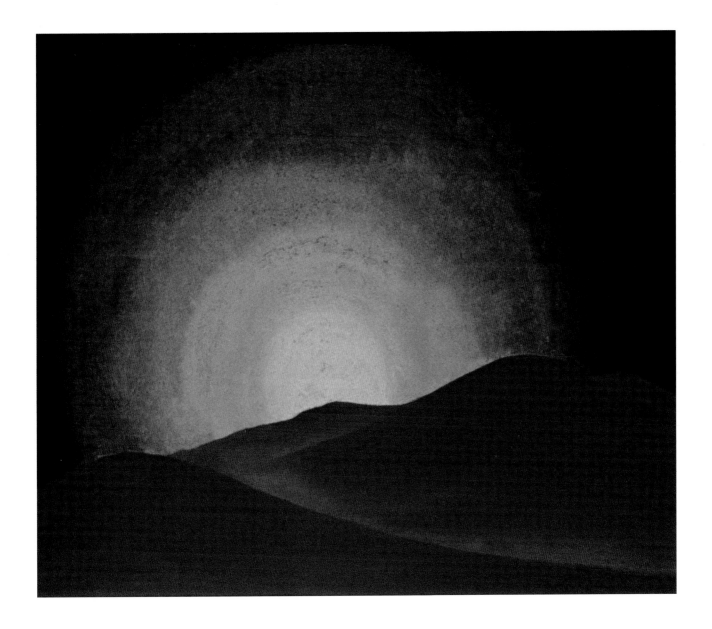

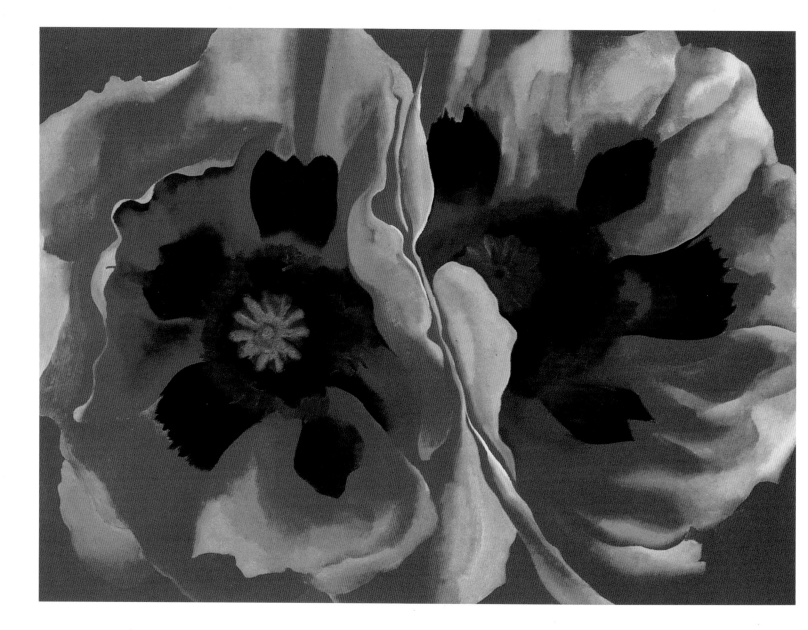

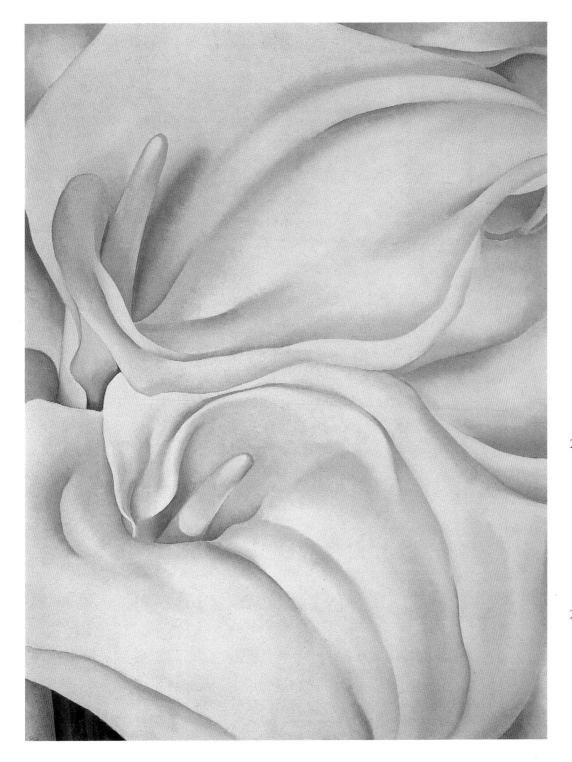

24. *Oriental Poppies,*
 1928.
 Oil on canvas,
 76.2 x 101.9 cm.
 Weisman Art
 Museum,
 Minneapolis.

25. *Two Calla Lilies on*
 Pink, 1928.
 Oil on canvas,
 101.6 x 76.2 cm.
 Philadelphia
 Museum of Art.

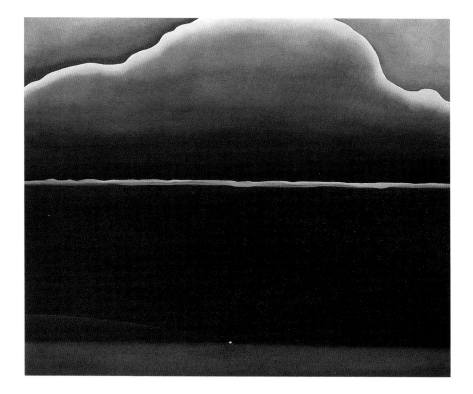

26. *Wave, Night,* 1928.
Oil on canvas,
76.2 x 91.4 cm.
Addison Gallery of
American Art,
Andover.

The situation at home was worse than the day she had left. Her father had moved the family into a cinder block house he had constructed, using leftover materials from his failed building supply company. Her mother, suffering from tuberculosis, spent her days on the porch outside her upstairs bedroom. Eventually Ida recovered enough to move to Charlottesville, Virginia. To bring in money, she and the other daughters rented a house and took in student boarders from the University of Virginia. Georgia and Francis stayed behind to help with the final moving arrangements.

In 1911, Elizabeth Willis, her former art instructor at Chatham, heard about Georgia's situation and asked her to fill in at Chatham while Willis took a leave of absence. Georgia readily agreed. The following summer in 1912, she and her sisters studied at the University with Alon Bement who employed a somewhat revolutionary method in art instruction, originally conceived by Arthur Wesley Dow.

In Bement's class, the students did not mechanically copy nature, but instead were taught the principles of design using geometric shapes. They worked at exercises that included dividing a square, working within a circle and placing a rectangle around a

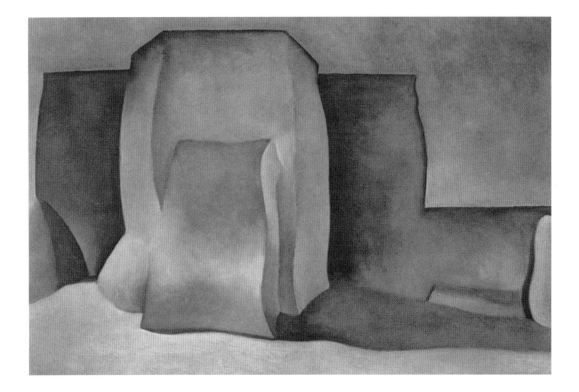

drawing, then organizing the composition by rearranging, adding or eliminating elements.

It sounded dull and to most students it was. But Georgia found that these studies gave art its structure and helped her understand the basics of abstraction. Georgia felt she had finally found someone to guide her and take her art to another level. She felt the Dow method actually served as a tool to work with, yet help her maintain her individualism. Georgia enrolled in Bement's advanced class, Drawing IV and quickly became one of his favorite students, impressing him with her skill and imagination. At the end of six weeks, she finished with a grade of 95.

Bement also offered to help her find a teaching position, despite the fact that she did not have a degree. Meanwhile, Georgia contacted several friends from school, telling them she was looking for a teaching job. Eventually a boarding school friend then living in Texas, told her of a position in Amarillo as a drawing supervisor. Georgia jumped at the chance to live in the west, her imagination fired with thoughts of cowboys, brilliant sunsets and distant mountains.

27. *Ranchos Church*,
 1929.
 Oil on canvas,
 61.3 x 91.8 cm.
 Phillips collection,
 Washington.

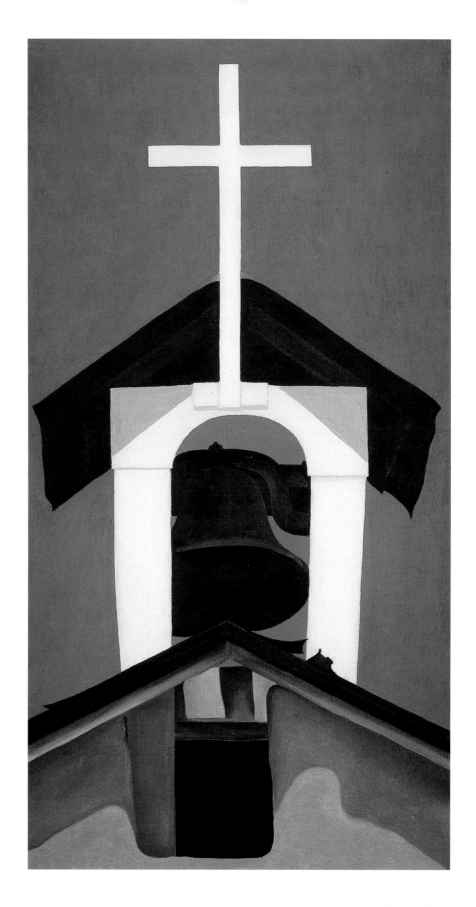

28. *Bell, Cross, Ranchos Church, New Mexico,* 1930. Oil on canvas, 72.2 x 40.6 cm. Private collection.

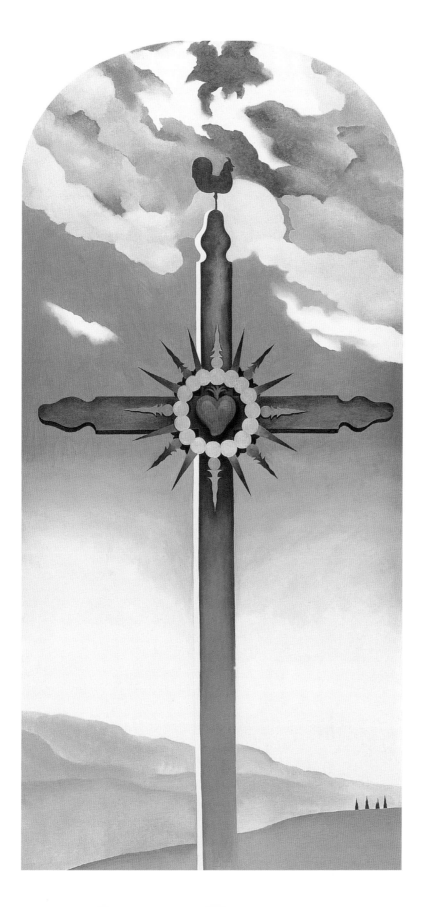

29. *Cross with Red
Heart,* 1932.
Oil on canvas,
211.6 x 101.6 cm.
Sacred Heart Chruch,
Margaretville.

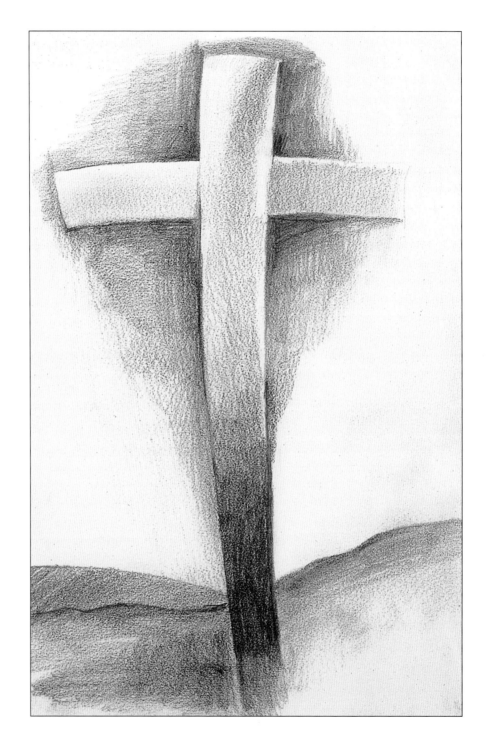

30. *Cross,* 1929.
Pencil on paper,
25.4 x 16.8 cm.
Georgia O'Keeffe
Museum, Santa Fe.

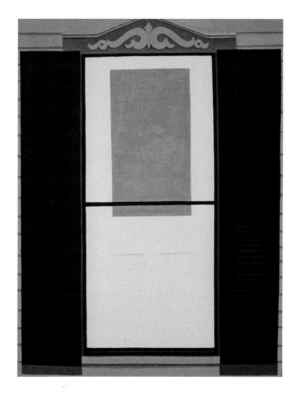

When she stepped off the train in Amarillo in 1912, she found it situated at the crossroads of two railroad lines and populated by merchants, saloon-keepers, lawyers and whores. Georgia seemed to enjoy living in the center of town where on several occasions she witnessed fights and shootouts. While other residents may have cussed at twisters, dust storms and spring flooding, she enjoyed the sudden changes in weather, and seeing cattle herds driven across the plains and into pens near the railroad station. When she returned to New York in 1914, the memory of the vast Texas prairie inspired the paintings *From the Plains I* a fiery yellow lightning-like curved shape cutting across a red-orange landscape, and *Orange and Red Streak,* (p. 12) a vibrant, swirling mixture of reds and yellows and muted greens against the dark, tranquil horizon.

Georgia's official duty was supervisor of drawing and penmanship for the several hundred students in Amarillo's six schools. Because of the lack of flora to use as subject matter for the children to draw, she employed Dow's philosophy that children should be encouraged to draw pictures from their everyday life, rather than force them to copy from art books.

31. *Lake George Window,* 1929. Oil on canvas, 101.6 x 72.2 cm. Museum of Modern Art, New York.

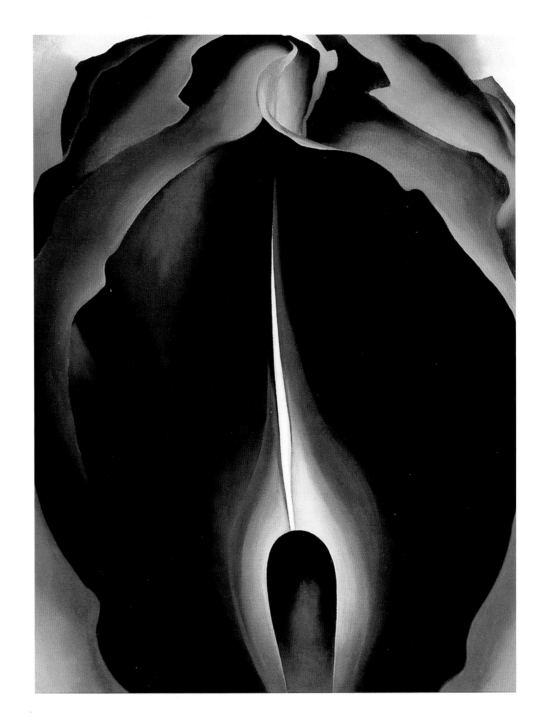

32. *Jack-in-the-Pulpit IV,* 1930.
Oil on canvas,
101.6 x 76.2 cm.
National Gallery of
Art, Washington.

33. *Jack-in-the-Pulpit III,* 1930.
Oil on canvas,
101.6 x 76.2 cm.
National Gallery of
Art, Washington.

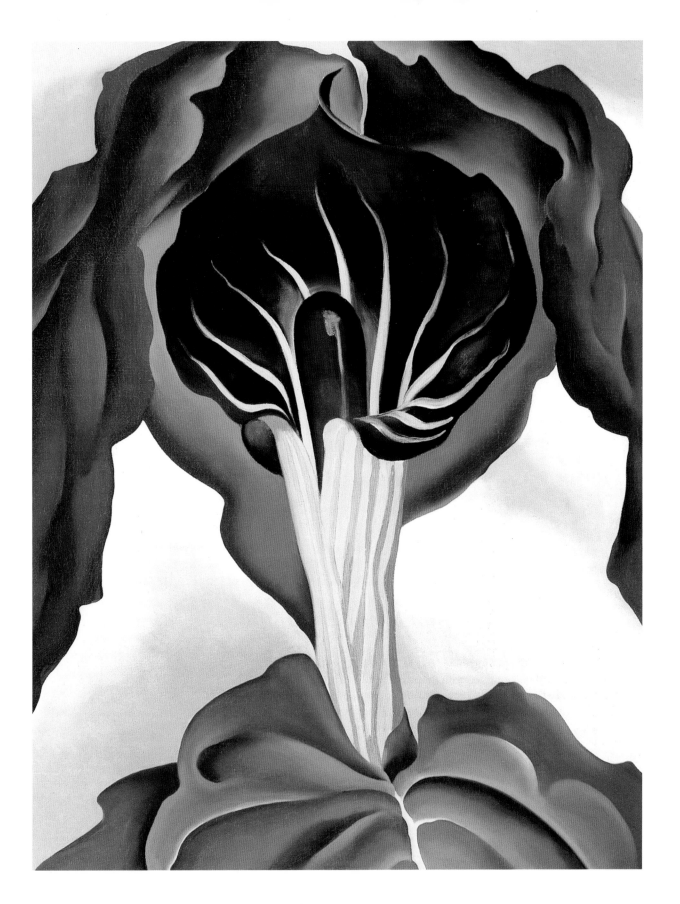

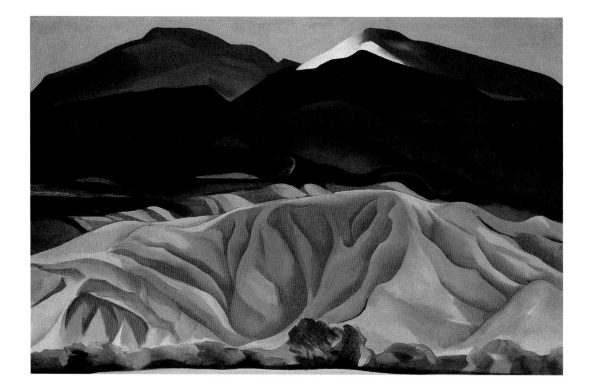

34. *Black Mesa
Landscape, New
Mexico / Outback of
Marie's II*, 1930.
Oil on canvas,
92.1 x 61.6 cm.
Georgia O'Keeffe
Museum, Santa Fe.

In 1913, she returned to Charlottesville for the summer and taught in the art department at the University of Virginia. As autumn approached, she received an offer to teach at another school for more money, but she preferred the raw, flat, unspoiled Texan plains and so returned to Amarillo in the fall for another year of teaching.

After teaching again at the University of Virginia the summer after, she heeded Bement's advice to return to New York and study with Arthur Dow at Teachers College of Columbia University.

The New York art world she had left in 1908 had now, in 1914, opened its doors and thoughts to the avant-garde art of the European painters and sculptors. In the social and political arena, a bohemian community sprang up in Greenwich Village where Freud, free love and socialism dominated conversations. Eugene O'Neill wrote daring new plays and Max Eastman produced outlandish political magazines. For women, issues such as birth control and women's voting rights had gained a foothold in American politics.

During her year at Teachers College, Georgia did excellent work in the creative classes but her teacher-education courses suffered.

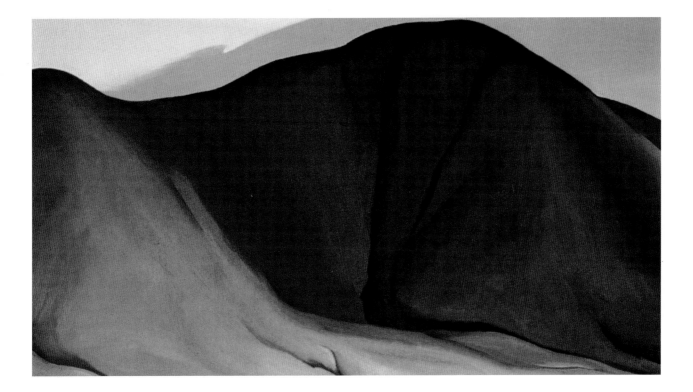

In 1915, Professor Dow extolled her abilities as an artist when he recommended Georgia for a teaching position. After claiming he had "heard" she did well as a teacher, he continued with complimentary remarks, including, "Miss O'Keeffe is... one of the most talented people in art that we have ever had."

As the school year wound down, she had the chance to visit Stieglitz during the show of watercolors by John Marin. Her practical side surfaced when she asked Stieglitz if the artist was actually able to make a living selling paintings such as these. She pointed out an abstract executed in blue crayon. When she was told that the painting had sold, she realized that she could have the best of both worlds – paint as she wished and earn money doing it.

In June, 1915, Georgia returned to the University of Virginia to teach summer art classes. The university still clung to the belief that women should not be afforded the same educational privileges as their male counterparts. They were allowed to participate in or serve as faculty members for the summer classes, but did not receive class credit for the summer courses.

35. *Purple Hills near Abiquiu*, 1935. Oil on canvas, 40.6 x 72.2 cm. San Diego Museum of Art, San Diego.

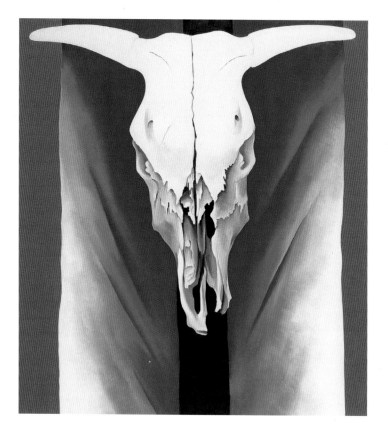

Nevertheless, Georgia shared her enthusiasm about the emerging modern artists with her students and how this next generation must embrace the exciting new ways of self expression.

When school ended, the approaching fall and winter forced Georgia to make some more decisions. The realities of earning a living wage, coupled with the desire to pursue her craft finally led to the decision to accept a teaching position at Columbia College in Columbia, South Carolina, a women's institution. The job allowed her time to paint as well as support herself. Although the salary was meager, she enjoyed the solitude that gave her time to paint, draw, and take her customary long walks in the woods and flower-rich countryside.

This also allowed her time to assess her work and consider whether the work was really hers, or the vision of other artists who had served as instructors. She realized, as she stared at the group of paintings and drawings on the wall, that she had not given reign to her own way of seeing, that there were images inside her that were hers alone, yet she had not expressed them in her art.

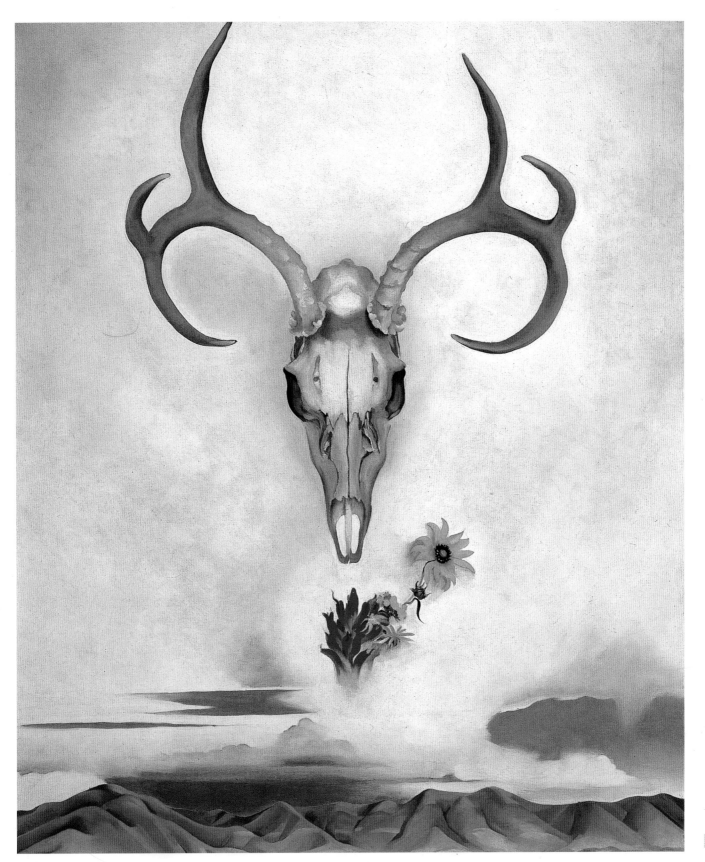

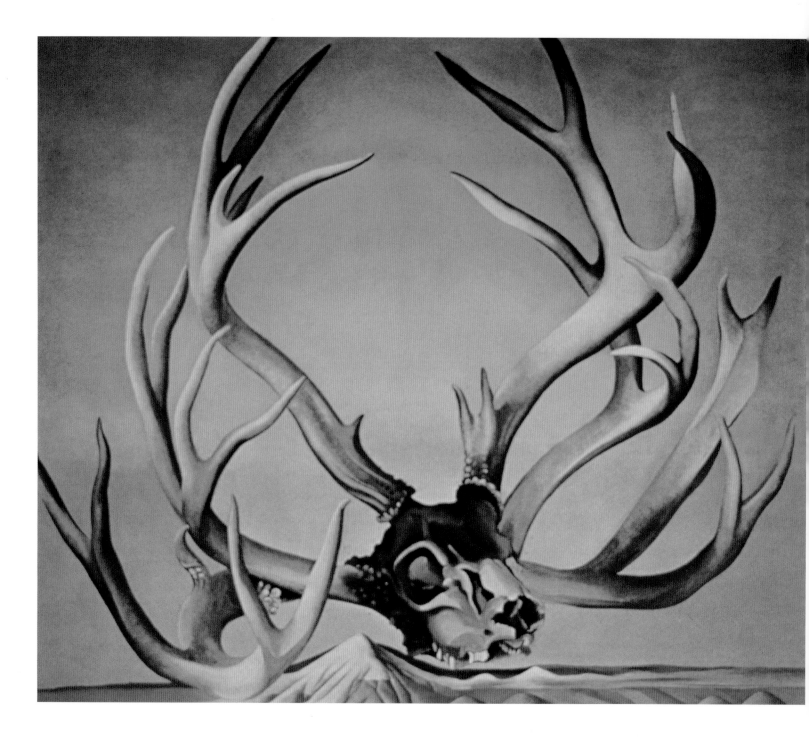

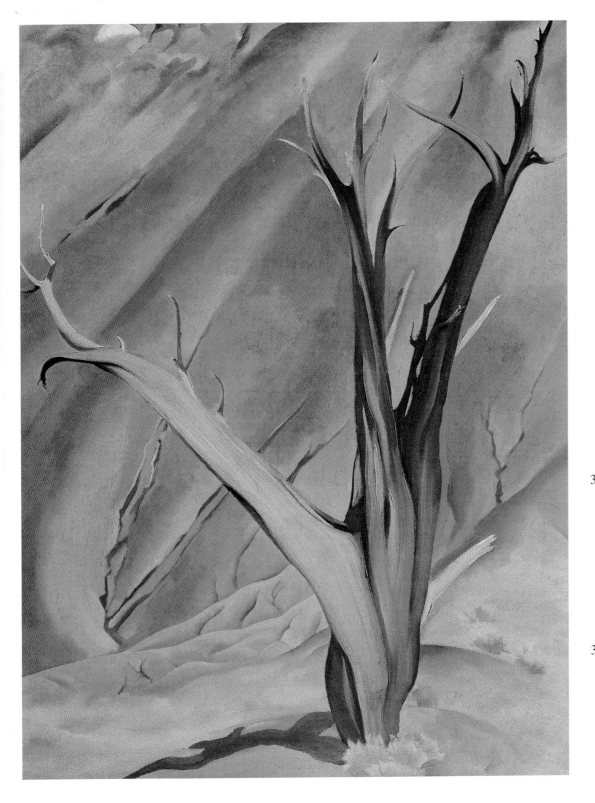

38. *From the Faraway Nearby,* 1937.
Oil on canvas,
91.2 x 102 cm.
Metropolitan
Museum of Art,
New York.

39. *Gerald's Tree I,*
1937.
Oil on canvas,
101.6 x 76.2 cm.
Georgia O'Keeffe
Museum, Santa Fe.

So, in a sense she began with the basics and worked only in black-and-white charcoal, until as she stated in her autobiography, she "decided not to use any color until it was impossible to do what I wanted to do in black and white."

Georgia's thoughts, as she struggled with the philosophical aspects of her art and whom to paint for, always went back to what she had heard from Stieglitz, his ideas and belief in the freedom of artistic expression. In March of that year, Georgia returned to New York once again to study with Arthur Dow. She had been offered a teaching position at West Texas State Normal College in Canyon, Texas, but one of the requirements was completing a course with Dow on teaching methods. She resigned from Columbia College immediately and set out for New York and Dow's classes, glad for the excuse to get back to the vibrant art world she loved.

At some point that year, Stieglitz came into possession of several O'Keeffe drawings, but no one mentions how he got them. This led to a heated confrontation. Although she had heard that he had them and intended to show them she was still shocked when given the news. Georgia immediately headed over to 291; Stieglitz was alone in the gallery. In a quiet, but dignified voice, she asked him to remove her work from his walls.

"You do not know what you have done in those pictures?" he asked.

"Certainly I know what I've done," she replied. "Do you think I'm an idiot?"

"Intellectually, you do not know what you've done," he answered. "In reality you do."

Stieglitz, never at a loss for words, talked on about the drawings and their worth, and in the end Georgia left. The drawings remained on the wall.

In September, 1916, Georgia arrived in Canyon Texas to take up her duties as head of the art department at West Texas State Normal College. Her teaching duties consisted of design and interior decoration for the home economics majors. As she had in her previous teaching positions, she tried to inspire them to see the beauty in the surrounding harsh, sometimes forbidding landscape they called home. Everything, she told her pupils, had an aesthetic quality, whether it be the shapes within a dress pattern, the placement of windows in a home or even addressing a letter.

But Georgia, however much she loved the land, also felt the pull of Stieglitz's influence, and it was his approval she sought and anticipated for future 291 showings. In April, 1917, Stieglitz entered two of Georgia's works in the Society of Independent Artists exhibition.

40. *Mule's Skull with Pink Poinsettias*, 1936.
Oil on canvas, 101.9 x 72.2 cm.
Private collection.

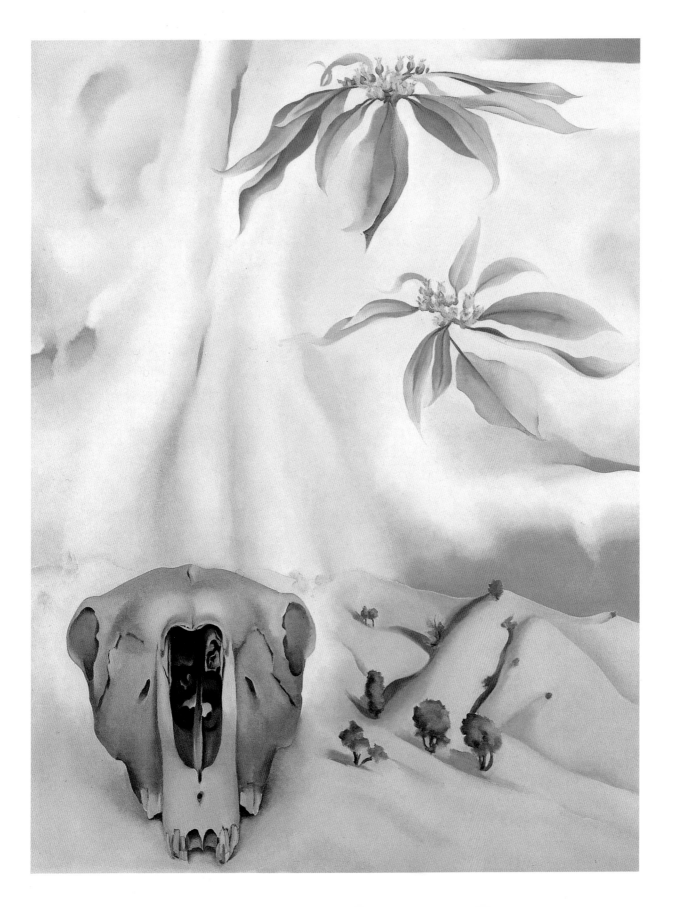

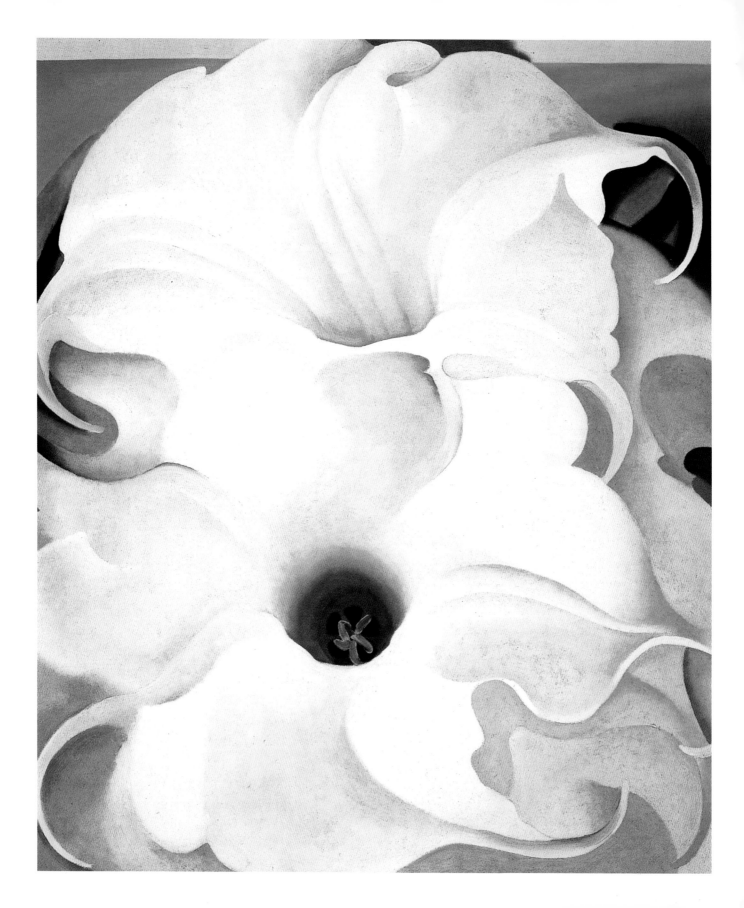

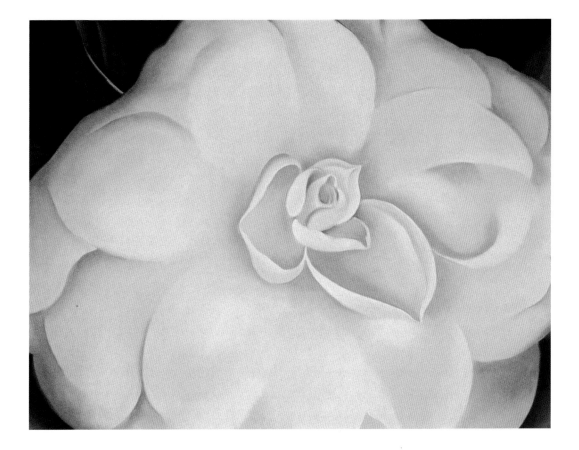

That same month, he gave O'Keeffe her first one-person show at 291. For both Stieglitz and Georgia, this was a bittersweet period in their lives. Georgia began her fall teaching session at WTSNC. Stieglitz, meanwhile, was depressed. He missed Georgia and felt that it was she who embodied the spirit of the now defunct studio 291. Stieglitz's marriage had been foundering for some time. His wife, Emmy had little interest in her husband's projects and lacked the spirit and zest for life that Alfred found so appealing in Georgia. So it was no surprise when Georgia took up residence in his niece's small studio apartment on East 55th Street.

The Stieglitz family had no problem accepting Georgia into the clan. Georgia and Alfred spent a delightful few weeks at the Stieglitz summer home at Lake George in the Adirondacks, and the rest of the family, who never cared much for Emmy, was delighted with Alfred's new love. The vacation also gave Georgia time to paint in oils and Alfred a renewed enthusiasm for his craft, taking joy in photographing the woman he loved.

41. *Two Jimson Weeds*,
 1938.
 Oil on canvas,
 91.4 x 76.2 cm.
 Private collection,
 Santa Fe.

42. *White Camellia*,
 1938.
 Oil on canvas,
 52.4 x 70.2 cm.
 Private collection.

As the summer waned, it was time for Georgia to decide whether or not to return to Canyon. The town's conservative atmosphere now held little attraction for her, whereas Stieglitz and his love, encouragement and the excitement of New York drew her in. She also had a taste of freedom – the freedom to paint without the demands of work-related duties. Stieglitz promised that somehow he had to find a way to support her so she could pursue her craft. The decision was easy, and in the fall, Stieglitz moved into the little studio apartment on 55th Street. Throughout this period, from the time Georgia and Alfred began their relationship in 1918 – probably earlier – she had talked of wanting children and felt her life would be incomplete without the joys of motherhood. Stieglitz had other ideas. His relationship with his own daughter, in college by that time, was at best, strained. Not only that, but he was now 60 years old. Moreover, he feared that the responsibilities of motherhood would drain Georgia's energies and keep her from doing what she was meant to do – create. Apparently, Georgia after seeing the public's reaction to her 100 – painting exhibit, realized that she could indeed be successful as an artist and devoted herself to her work, abandoning all thoughts of motherhood.

By 1922, Stieglitz's wife, Emmy, realized that the chances of her husband returning to her were nonexistent and filed for divorce. This left Georgia free to marry her lover, yet she resisted. She felt they had weathered all the gossip surrounding their living arrangements, so there seemed to be no reason to go through the motions of a ceremony now. Eventually she gave in, and on December 11, 1924, the couple took the ferry to New Jersey, where the laws governing divorce and remarriage were more lenient. The ceremony itself – without an exchange of rings – included only the simplest of vows. The bride, once again fiercely independent, did not utter the words "love, honor and obey."

Alfred and Georgia shared many similarities. He disliked deceit and so her honesty pleased him. Both insisted on working with only the best materials – Alfred used the finest photographic paper and Georgia the highest quality paints. It is believed that this is the reason her paintings have retained their brilliance over the years.

"… We found we were co-workers," Stieglitz said years later. "We believed in the same things."

She, however, resented the sexual connotations people attached to her paintings, especially during the 1920s when Freudian theories became a form of what today might be termed "pop psychology."

43. *Stump in Red Hills*,
 1940.
 Oil on canvas,
 72.2 x 60.9 cm.
 Georgia O'Keeffe
 Museum, Santa Fe.

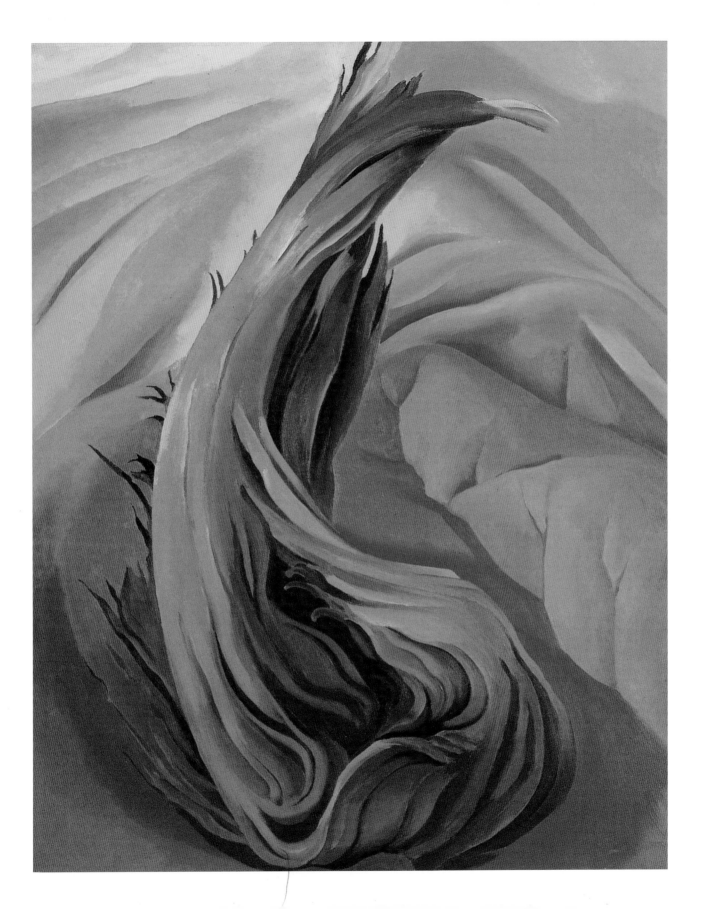

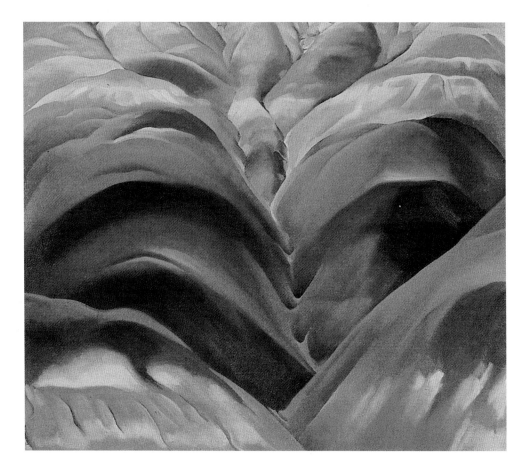

44. *Grey Hills*, 1942.
Oil on canvas,
50.8 x 76.2 cm.
Indianapolis
Museum of Art,
Indianapolis.

In *Calla Lily with Roses*, it has been observed that the lily with its stamen reflects Georgia's uninhibited pre-occupation with sex, especially since the lily dominates the painting while the feminine rose hovers in the background. Even years later, she threatened to stop painting if people continued their obsession with connecting Freudian premises to her work.

She also took issue with the "woman artist" label attached to her work. To be sure, there were other female painters at the time, but none of Georgia's stature. Pre-twentieth century convictions determined that a woman's place was in the home, that motherhood took too much time away from pursuing the arts and a childless woman could not possibly possess the same deep-seated feelings as one who had experienced the miracle of childbirth. Stieglitz was there to dispute this and insisted there was no difference between the male or female creative process.

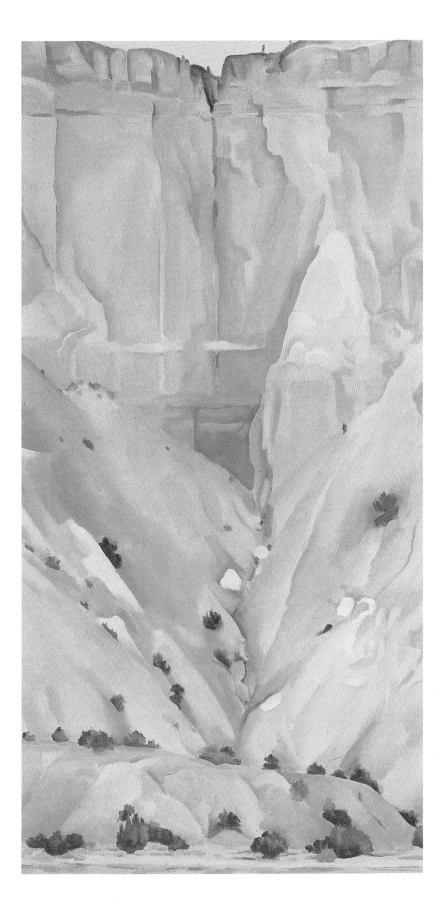

45. *Cliffs beyond
 Abiquiu, Dry
 Waterfall*, 1943.
 Oil on canvas,
 76.2 x 40.6 cm.
 Cleveland Museum
 of Art, Cleveland.

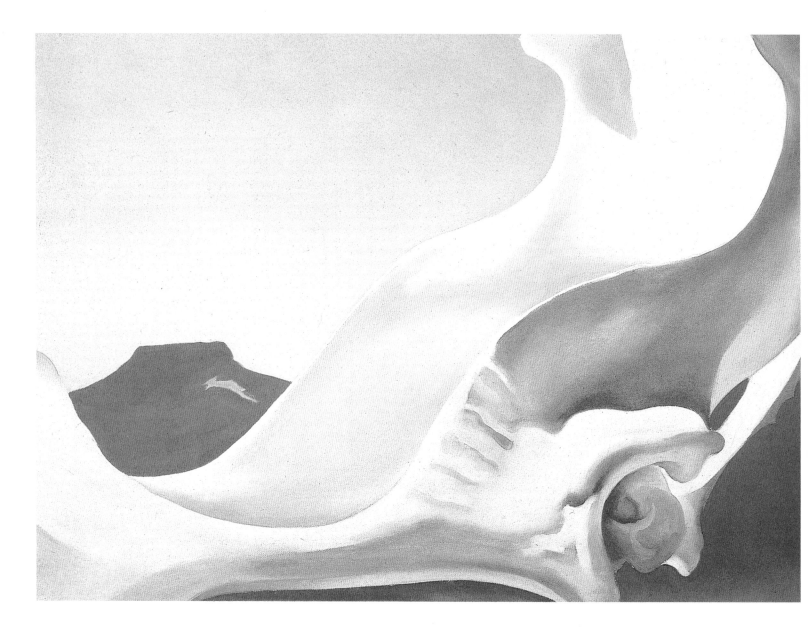

In February, 1926, Georgia was asked to address the National Women's Party Convention in Washington, D.C. The Party provided a means by which women sought to achieve equality and recognition, and was instrumental in securing the passage of the Nineteenth Amendment granting voting rights for women. Speaking at the convention, Georgia gave the women a practical approach to finding their independence. She advised them to break away from the centuries-old custom of dependence on men for financial support and concentrate on their abilities to make a living on their own. Her inspiration obviously came from her own life, and while most women were not blessed with her talent and the influence and support of an Alfred Stieglitz, it was her work and efforts to forge a new way of seeing that had caught her mentor's attention in the first place.

By the late 1920s, there were few times when an O'Keeffe painting was not being shown somewhere in New York. In January and February, 1927 she exhibited at the Intimate Gallery. During the summer of that year, the Brooklyn Museum had a small retrospective of her work. And from December through January, she was part of a group exhibit at the Opportunity Gallery.

Georgia was now earning a very comfortable living as an artist, painting to please herself and gaining public approval as well. She again exhibited at the Intimate Gallery in the winter of 1928. Time magazine featured a story on it, but one sale from the exhibit stunned her, earning far more than she had altogether the previous year. A Frenchman offered to buy six of her small calla lily paintings done in 1923. Stieglitz possessed a certain snobbishness when it came to selling an O'Keeffe painting; the buyer had to be "worthy" of the work, and perhaps he felt that the gentleman had no appreciation for the paintings' intrinsic value. Stieglitz picked a price of $25,000. The client agreed. Stieglitz was as much overjoyed by the fact that a European had purchased an American work of art as the money Georgia received for it. Not only that, but unlike many Americans, Georgia's art education had taken place in the United States; this should make Americans aware, Stieglitz claimed, that there were artists outside of France. While the newspapers proclaimed her an overnight success, in the interviews that followed Georgia emphasized that it took years of study, soul-searching and working to earn a livable wage to get where she was.

46. *Pelvis with Pedernal*,
1943. Oil on canvas,
40.6 x 55.9 cm.
Munson-Williams-
Proctor Institute
Museum of Art,
Utica.

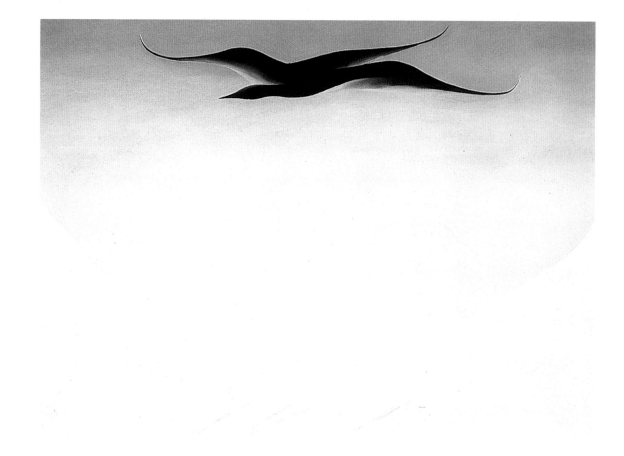

47. *A Black Bird with
Snow-Covered Red
Hills*, 1946.
Oil on canvas,
88.9 x 121.9 cm.
Private collection.

48. *Pelvis III*, 1944.
Oil on canvas,
121.9 x 101.6 cm.
Private collection.

Georgia had also sought to create murals in public buildings. Then, in 1932, the Museum of Modern Art invited over 60 artists and photographers – Georgia among them – to enter their works in a competition for the massive walls of the museum's new headquarters. Artists were required to submit a drawing for a three-part mural and complete one panel in a nearly impossible six week time frame. O'Keeffe's entry of "Manhattan" resembled some of her New York paintings (skyscrapers tilted, a moon hanging over a building, dancing roses). Her submission resulted in a request to do a mural surrounding the hall's nine round mirrors, as well as the second mezzanine powder room. Georgia was thrilled and signed a contract to produce the work for the incredibly low rate of $15,000 – but this was the Depression.

Also in 1936, Georgia was commissioned by Elizabeth Arden to create a painting for her exercise salon in New York. Arden already had a large O'Keeffe petunia hanging in her elegant Fifth Avenue apartment. This was ironic, since Georgia, with her severe clothes and lack of makeup, did not fit the image of an Elizabeth Arden client.

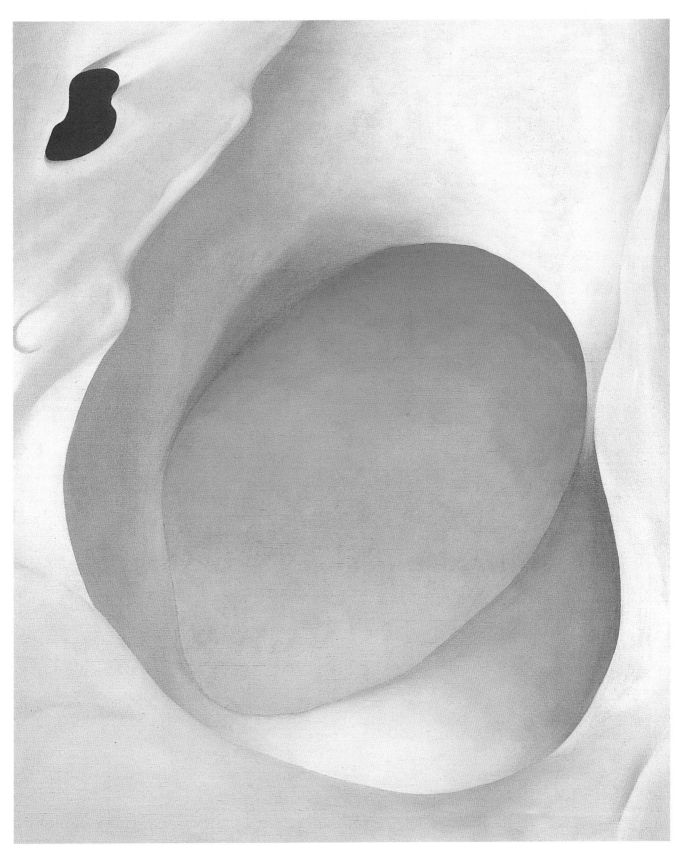

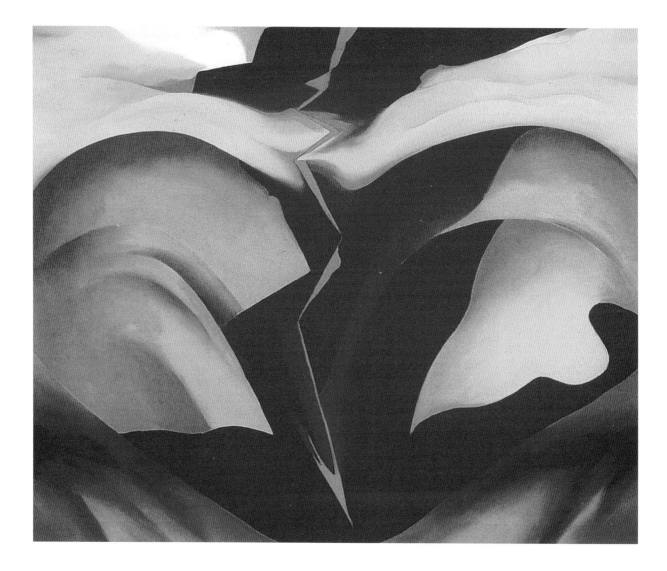

49. *Black Place IV,*
 1944.
 Oil on canvas,
 76.2 x 91.4 cm.
 Private collection.

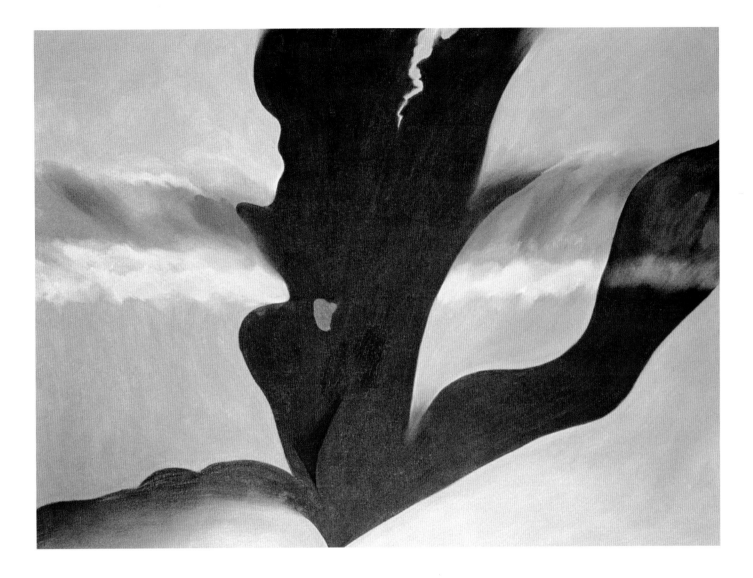

50. *Black Place Green,*
1949.
Oil on canvas,
96.5 x 121.9 cm.
Whitney Museum
of American Art,
New York.

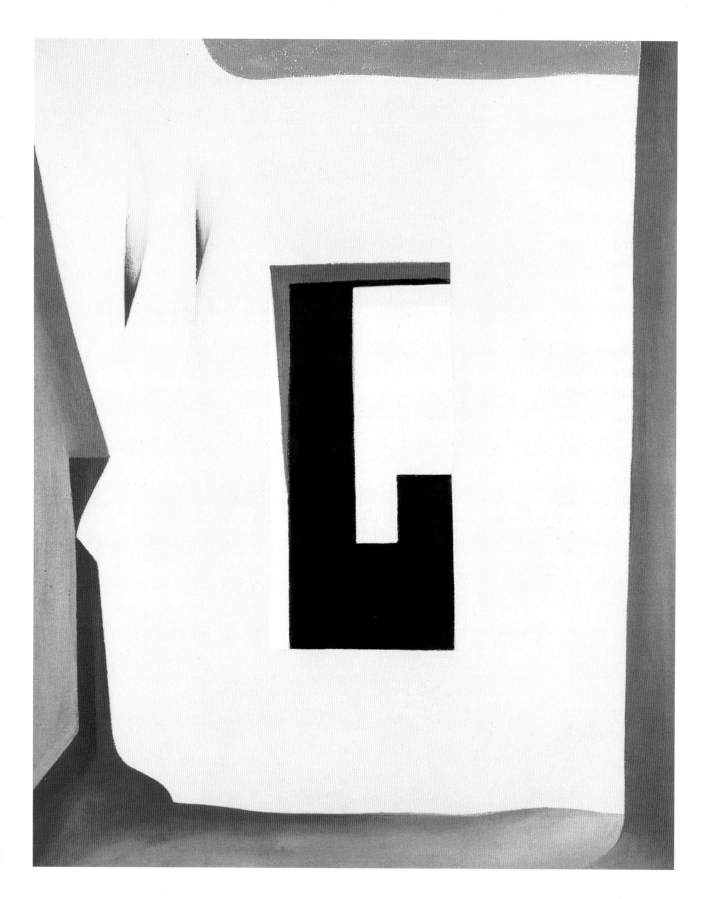

A photo in Life Magazine for a feature on her in 1938, shows Georgia in front of the painting, one of her large images of lilies, their curved edges and soft colors swirling behind her as she stands with her arms folded across her waist, her high cheekbones and hair drawn away from her face.

In October, 1936, Georgia's fame as an artist was also firmly established; the time had come, she knew, to allow herself more room to create when she was in New York.

In spite of his poor health and need for greater care, Stieglitz came to accept Georgia's long stays in the west. Their marriage became one of tender understanding in its later years. In addition to implying that he was sacrificing his company with her for the sake of art, he said he would rather have six months with her than a year with anyone else. She, in turn wrote to him daily when she was away.

In spring, 1938, Alfred suffered the first of several heart attacks. This, coupled with a bout of pneumonia, nearly killed him. A live-in nurse cared for him during the five-week recovery period. Even then, the sickness lingered for six months; the medical miracle of antibiotics was decades away.

Meanwhile, the first of many honorary degrees was presented to Georgia by the President of the College of William and Mary in Williamsburg, where she had spent much of her adolescence. She felt flattered, since the only diploma she had received was from her high school. Georgia received another honor during this period that put her in the company of such esteemed women as Eleanor Roosevelt. A committee of the New York World's Fair included her in its list of the 12 most outstanding women in the past 50 years. Not only that, but her painting *Sunset, Long Island,* a bright sun suspended over dunes, was chosen to represent New York State at the Fair.

In 1942, Georgia and General Douglas MacArthur, commander of the Pacific forces, received honorary Doctor of Letters degrees from the University of Wisconsin. Although she had been criticized for her apathy toward the war in 1917 while living in Texas, she felt encouraged this time that the university was recognizing an artist along with a high profile military officer. The visit to the country that had first shaped her was a sentimental and nostalgic one as Georgia stood to receive her degree, and later visited with friends, relatives and Mrs. Edison, school teacher at Sun Prairie.

Another connection with her past surfaced in 1943. Daniel Catton Rich, curator of the Art Institute of Chicago, had met Georgia in 1929 in Taos, and again in New York in 1942.

51. *In the Patio I,* 1946. Oil on canvas, mounted on cardboard, 76.2 x 61 cm. San Diego Museum of Art, San Diego.

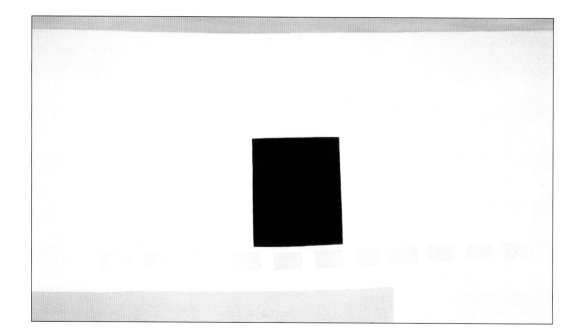

In the course of reminiscing about the stark beauty of New Mexico, Rich mentioned that he was interested in having a retrospective of Georgia's work at his museum. She readily agreed. This would be Georgia's first big retrospective, and ironically, featured in the Midwest's largest museum and at the school where she had been a student nearly forty years earlier. The show opened on January 31, 1943, with a total of 61 works altogether, created between 1915 and 1941. Reviews were mixed but generally the show was well-received by the public; most viewers found the brilliance of her colors and the clarity of her vision and her love of nature cheering in the middle of a gray winter in wartime.

During the New Mexico years, Georgia's intense craving for privacy increased to the point of obsession. She maintained a strict work schedule, avoided the artists colony in Taos and thought little of the Museum of Fine Arts in Santa Fe, which showed works by virtually any artist who happened to reside in the state.

In May, 1946, Georgia had another major exhibit, this time at the Museum of Modern Art in New York. Fourteen of the works exhibited had been shown at An American Place the previous winter. Fifty-seven paintings in all, done between 1915 and 1945 and hung in chronological order, were showcased. As with other exhibits, this one was also well-received.

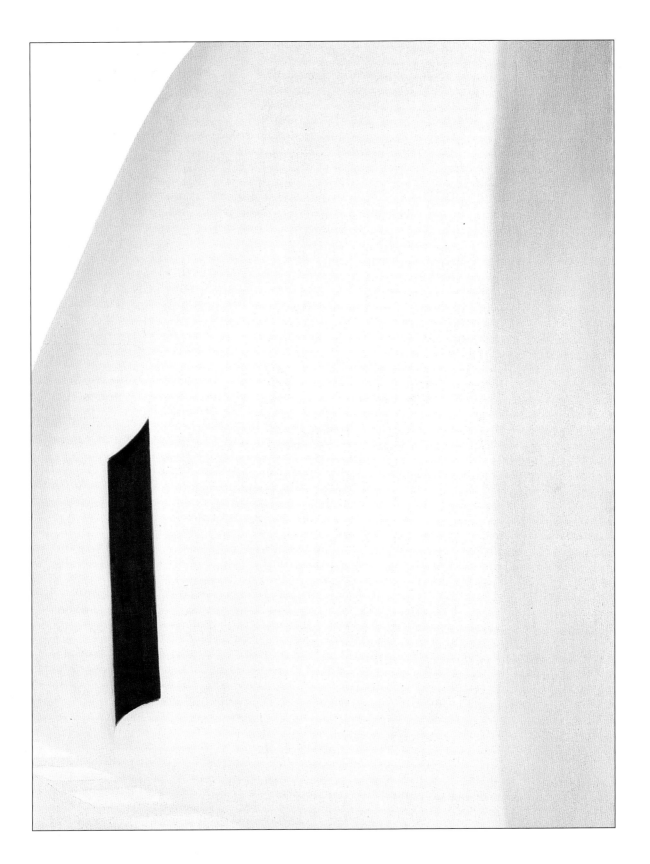

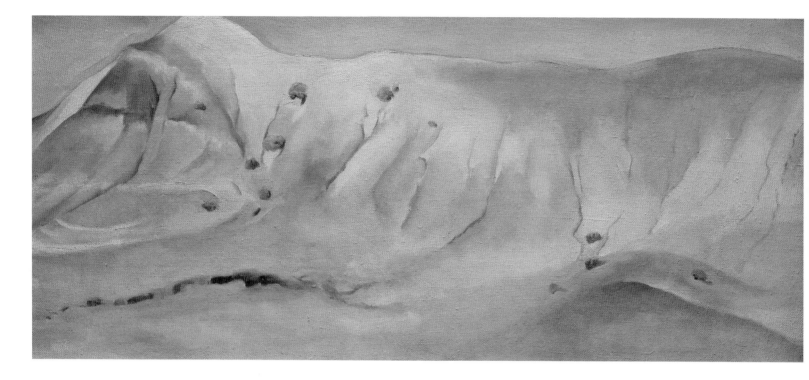

54. *Lavender Hill with
Green*, 1952.
Oil on canvas,
30.5 x 68.9 cm.
Georgia O'Keeffe
Museum, Santa Fe.

On July 6, 1946, Stieglitz suffered a heart spasm, followed by a stroke a few days later, which rendered him unconscious. He was found on the floor of the apartment and taken to the hospital. Georgia received a telegram advising her that Alfred had suffered cerebral thrombosis and his condition was critical. She left immediately for New York, but by the time she arrived he was already in a deep coma. Stieglitz passed away in the early hours of July 13, 1946. The funeral arrangements were simple, but Georgia, still independent and intent on perfection, found the pink lining in the casket offensive and spent most of the night ripping it out and inserting white linen lining in time for the memorial service on Sunday. In accordance with his wishes, no music was played nor eulogies read. Stieglitz's body was cremated and his ashes buried at the foot of a pine tree on the shore of Lake George. Georgia, as usual, was not given to obvious displays of emotion, but those who knew her best were aware that, although prepared, she deeply felt the loss of her lover and mentor and wished she could share her world with him.

Following Alfred's death, Georgia was suddenly thrust into the role of curator of his collection, which numbered 850 works of art, hundreds of photographs and tens

of thousands of letters. Most of the paintings were sent to the Metropolitan Museum of Art, others to the Art Institute of Chicago, and the rest were scattered among smaller institutions.

Between the time of Alfred's death and 1948, Georgia painted little, although she did spend her usual summers in Abiquiu where the demands on her time revolved around remodeling her house. In 1947, the Museum of Modern Art held a Stieglitz retrospective.

In 1949, Georgia bid goodbye to the city that launched her career and settled permanently in New Mexico, dividing her time between Abiquiu in the winter and Ghost Ranch in the summer. That same year she directed the establishment of the Art Gallery of Fisk University, an institution founded for black students. It is believed Georgia had a number of reasons for choosing Fisk. There was the close relationship she had with black writer Jean Toomer; also the black Tennessee artist Beauford Delaney was the subject of several charcoal drawings, and one of the few people whose images she portrayed. In addition, a friend of hers was acquainted with another black artist, Aaron Douglas, founder of the university's art department. She developed a solid working relationship with a lame black man who was in charge of the other building workers as well as the head of their local union. At one point he asked Georgia to speak at a union meeting. She found the experience exhausting, but in a letter to Daniel Catton Rich, she told of a conversation with a young black girl who impressed her when she asked why the idea of purity is associated with white rather than black. "She wanted only to be a person," Georgia wrote, "That black girl had something that made me discount the color of her skin as I never have with any other colored person"

Georgia's ties to New York were not quite cut even after she disposed of Stieglitz's collection in 1949. Along with John Marin, she attempted to keep An American Place going, but without Alfred at the helm, the spirit did not seem to be there.

In 1949, Georgia was honored to be elected to the blue-ribbon National Society of Arts and Letters. Her selection carried other distinctions as well – she was in the company of such talented people as artist Gertrude Lathrop, E.E. Cummings and Christopher Isherwood, and only 10 percent of the institute's members were women.

Georgia had reached a point in her career where it was no longer necessary to maintain a schedule of high-profile shows in order to sell her work. She produced fewer paintings during the 1950s, and during that decade had only three one-woman shows.

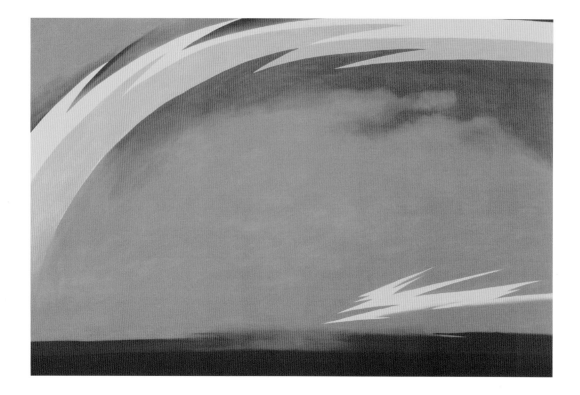

Between 1950 and 1973, she spent more time traveling, accepting honorary degrees and exhibiting the work that she did create. Reviews of her work, laudatory or apathetic, no longer interested her, as she divided her time between Abiquiu and Ghost Ranch.

Two years later, she took her first trip to Europe and traveled for the next two months to France and Spain. While France had been the center of the art world for so many decades and the birthplace of Impressionism, in many ways it left Georgia cold. She even passed up the opportunity to visit with Pablo Picasso, stating that since she did not speak French and he did not speak English, there seemed little point in the two talking through a translator. In Spain, she felt a connection with the works of Goya, his use of light and shadow in his works depicting cruelty and unrest.

In spring, 1956, she spent two months in Peru, intrigued, yet frightened of the mountains stretching into the mist; the Indians seemed mysterious, as if they were privy to some terrible secrets. Yet, as with two other Spanish speaking countries – Mexico and Spain – she called Peru one of the best places in the world to visit.

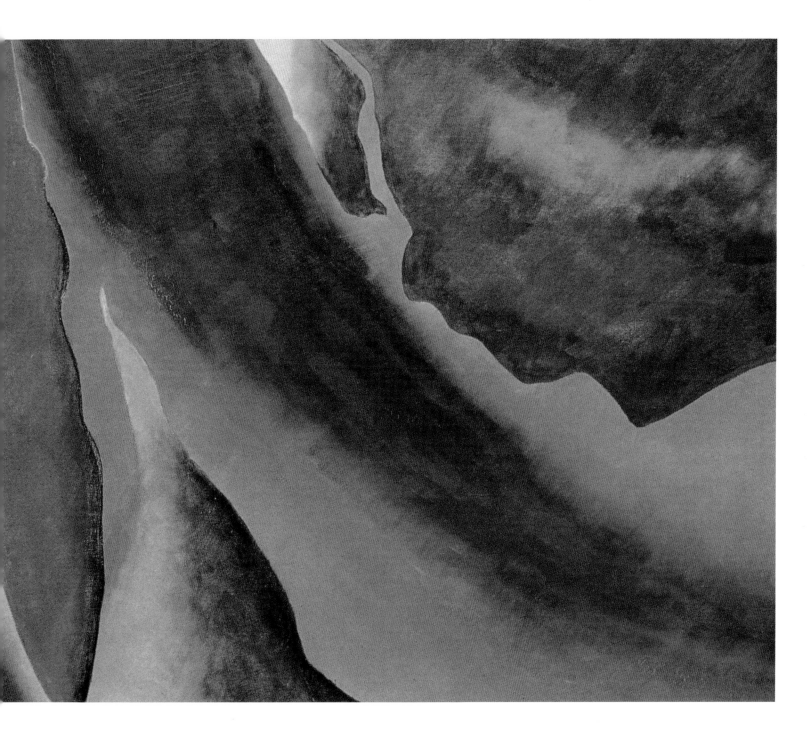

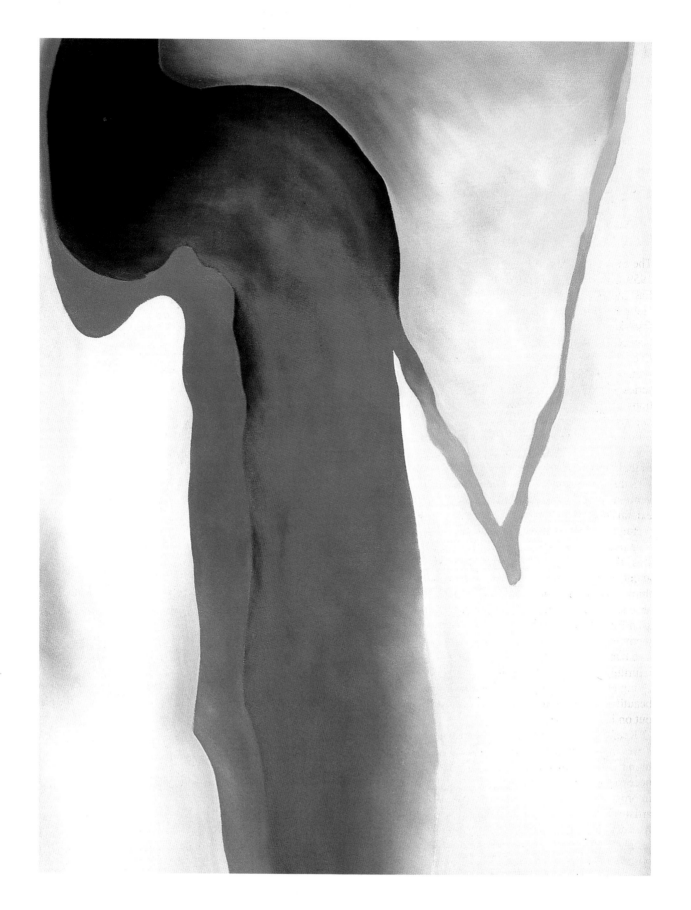

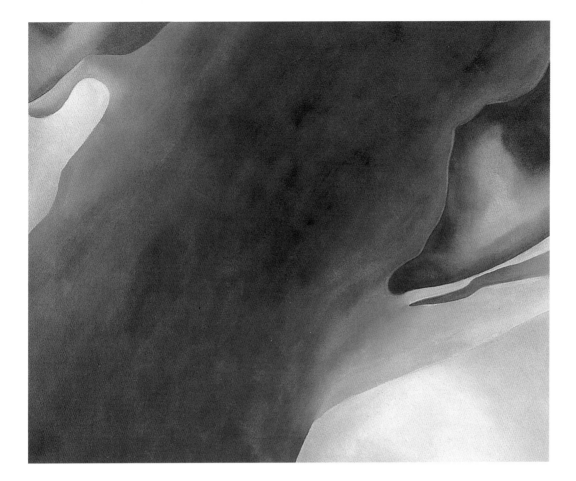

Only four watercolors embody her visit to Peru, one of which is *Machu Picchu (Peruvian Landscape)*, showing bold intense blue peaks advancing toward more brilliant peaks, all fighting for space with the sky.

In 1959 Georgia decided it was time to take a trip around the world. She started in San Francisco, crossed the Pacific to Tokyo, Hong Kong, Taiwan, India, the Middle East, Italy and ended in New York. She spent several weeks in India and only a short time in Italy – the Renaissance masters she found "vulgar." Feeling a strong connection with Asia, having gravitated toward its simplicity of form when other artists launched into cubism in the early part of the twentieth century or abstract expressionism decades later, Georgia traveled again to Asia in 1960.

In spring, 1961, Georgia had her last exhibit at the Downtown Gallery in New York. Between 1966 and 1971, Georgia received various honors, many from areas which helped shape her life as an artist.

57. *Blue, Black and Grey,* 1960. Oil on canvas, 101.6 x 76.2 cm. Private collection.

58. *Blue B,* 1959. Oil on canvas, 76.2 x 91.4 cm. Milwaukee Art Museum, Milwaukee.

These included: the Wisconsin Governor's Award for Creativity in the Arts, and an Honorary Fine Arts degree from the Art Institute of Chicago, a Distinguished Service Citation in the Arts from the Wisconsin Academy of Sciences, Arts and Letters; an Honorary Doctor of Humane Letters degree, Columbia University, New York; an Honorary Doctor of Fine Arts degree, Brown University in Providence, Rhode Island and the M. Carey Thomas Award from Bryn Mawr College – citation for distinguished contributions to the visual arts from the National Association of Schools of Art.

Then in 1971, she became afflicted with the loss of her central vision. Now everything she viewed was blurred. The degenerative condition of her eyes was irreversible. Her inability to see objects clearly proved so frustrating, that she stopped painting altogether for the next several years.

Over the years several people had asked Georgia to write about her works and history as an artist. But she had always felt that the written word had no place when it came to art, and she never liked writing about herself. Yet she made some notes occasionally over the years, and in the mid 1970s, friends encouraged her to begin writing her autobiography. She relented and entered into a contract with Studio Books, a division of Viking Press in New York. Her adopted apprentice, Hamilton, oversaw the project, serving as the pair of eyes she needed to help choose transparencies, layouts and proofs. The book came out in the fall of 1976, and received high praise for its faithfulness to her way of speaking and her struggle to create her own vision.

By this time, Georgia had apparently mellowed to the idea of being a public figure and permitted a television crew to spend five days documenting her world in the fall of 1975. The award-winning film was shown in November, 1977, in Washington, D.C. A reception followed at the National Gallery of Art, currently exhibiting a joint showing of her paintings and Stieglitz's photographs.

In autumn of the following year, the Metropolitan Museum in New York featured "Georgia O'Keeffe: A Portrait by Alfred Stieglitz," an exhibit of fifty-one photographs. Georgia and Juan worked together to assemble the showing, which included some nudes seen for the first time.

By now, Hamilton had become the liaison between Georgia and the rest of the world, as well as her agent. The relationship nearly resembled the one between her and Stieglitz, as he gradually began to take over the handling of sales of her paintings.

59. *It was Red and Pink,*
1959.
Oil on canvas,
76 x 101 cm.
Milwaukee Art
Museum, Milwaukee.

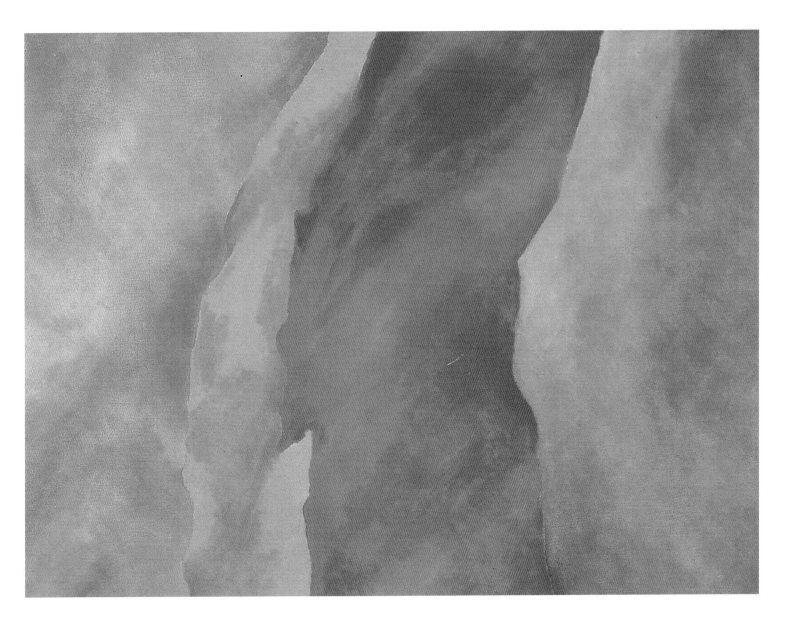

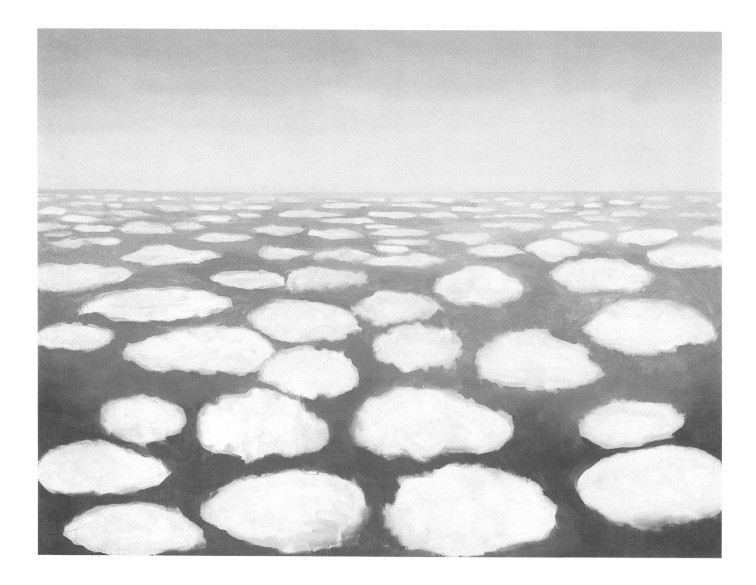

60. *Sky above Clouds I,*
 1963.
 Oil on canvas,
 91.7 x 122.5 cm.
 Georgia O'Keeffe
 Museum, Santa Fe.

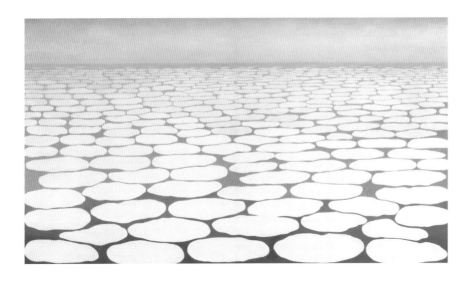

Doris Bry served as negotiator, cautiously marketing O'Keeffe's works to ensure that they retained their value. Only one or two works were offered for sale each year. Rarely selling to art dealers, Bry told purchasers that Georgia must have the right of first refusal, should they decide to sell. But as time went on, Bry now found herself pushed into the background. She did not agree with the way in which Hamilton dealt with art dealers, in her estimation, selling unconditionally at prices either too low or too high.

A complicated web of suits and countersuits developed over the next several years: Georgia fired Bry and sued for the return of her paintings Bry had kept in New York. Bry countersued, saying O'Keeffe had no right to fire her and her services were worth more than the standard 25 percent agent's commission. Hamilton also felt Bry's wrath, when he was served with a lawsuit stating that he had unduly pressured O'Keeffe to sever the relationship with her. Hamilton in turn, filed a defamation of character lawsuit.

Gossip flourished regarding the O'Keeffe-Hamilton relationship, and there was some speculation that the two would marry, since they took several trips together. Now well into her nineties, she traveled to Costa Rica and Guatemala in 1979, to Hawaii in 1982 and back to Hawaii the following year.

Then in 1972 she briefly found herself in the political arena, when she donated a small painting to a fund-raising auction benefiting George McGovern's presidential campaign. The $40,000 price it generated was reported in the press.

61. *Sky above Clouds IV,*
1965.
Oil on canvas,
243.8 x 731.5 cm.
Art Institute of
Chicago, Chicago.

Now that her name was connected to President Nixon's opponent, it was not long before she held the dubious honor of making the White House enemies list. An amused Georgia claimed to be delighted to be in the same place as so many other Americans. The "enemy" label was short lived. In January, 1977, she received the Medal of Freedom Award from President Gerald Ford.

All the way through to her late nineties, Georgia maintained a steady, but diminishing pace in her daily schedule. She rose early, worked with clay, walked with her dogs, enjoyed a glass or two of wine, wrote, and listened to music. She retired early shortly after sunset and had a housekeeper read to her from a book or magazines such as *Smithsonian*, *New West* or *Prevention*. She connected with old friends occasionally. She was also approached by the Museum of Fine Arts in Santa Fe asking her to approve the building of a wing for the purpose of exhibiting her work. But it was Georgia's wish that a separate building be erected to house her legacy. With that in mind, she considered buying back some of her best paintings she had produced during her lifetime.

In 1984, at Hamilton's urging, Georgia reluctantly moved to Santa Fe, where medical help was close by should she need it. Yet she was unwavering in her determination to reach the century mark, and later changed her goal of longevity to an ambitious 125 years. She came close. On March 6, 1986 at the age of 98, she became ill and was admitted to St. Vincent's Hospital in Santa Fe. She died a few hours later. When word reached Abiquiu, a resident ran to St. Thomas the Apostle church and began to ring the bells. The following day, Georgia Totto O'Keeffe was cremated, and as she wished, no funeral or memorial services were held. Juan Hamilton cast her ashes over the New Mexico landscape.

In July, 1997, the Georgia O'Keeffe Museum opened in Santa Fe, New Mexico – the first art museum dedicated to an internationally renowned woman artist and home of the largest collection of O'Keeffe works in the world. Its mission carries on the basic tenets that Georgia held onto throughout her life. The museum's research center sponsors research in art and architectural history, architectural design, literature, music and photography. In addition to its exhibitions, it continually offers education programs at all levels throughout the year.

The legacy she left behind is a unique vision that translates the complexity of nature into simple shapes for us to explore and make our own discoveries. She taught us there is poetry in nature and beauty in geometry. Georgia O'Keefe's long lifetime of work shows us new ways to see the world, from her eyes to ours.

62. *Road to the Ranch*, 1964.
Oil on canvas,
61 x 75.9 cm.
Private collection.

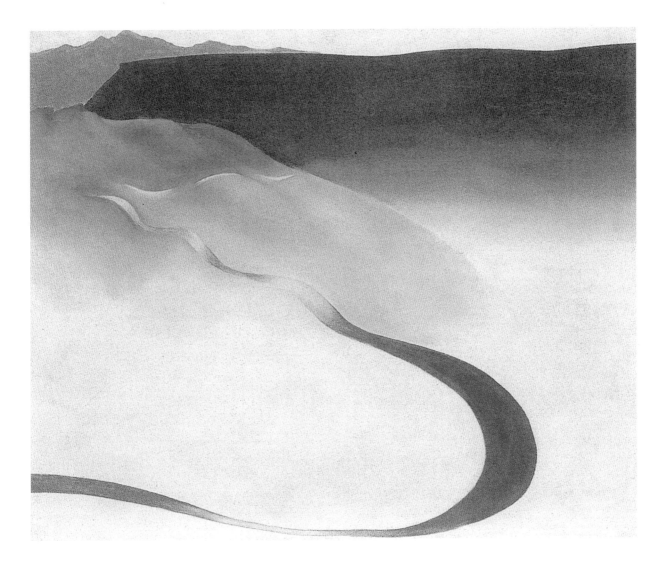

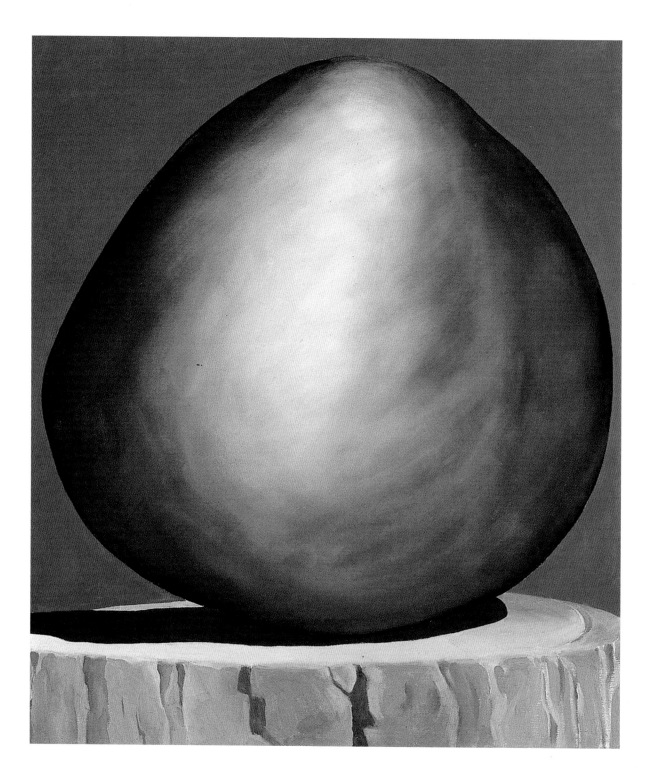

BIOGRAPHY

1887	Georgia O'Keeffe is born on November 15, 1887 in Sun Prairie, Wisconsin, the second of seven children of Francis Calyxtus O'Keeffe and Ida (Totto) O'Keeffe.
1902	The family moves to Virginia. She attends art classes for five years.
1905-06	Georgia studies at the Art Institute of Chicago.
1907-08	She studies at the Art Students League School in New York.
1908	She wins the League's William Merritt Chase still-life prize for her painting *Untitled (Dead Rabbit with Copper Pot)*.
1908-10	She temporarily abandons painting to devote herself to a career as a commercial artist, painting mainly for advertisements.
1912	She teaches art at Amarillo (in Texas) and at the University of Virginia.
1915	She teaches art at Columbia College in South Carolina. At the same time, whilst waiting to discover her own personal style, she begins painting abstracts in charcoal.
1916	She sends these paintings to a friend, Anita Pollitzer who shows them to the renowned Alfred Stieglitz. Georgia returns to New York to teach at Teachers College.
1917	Her first exhibition opens in April at the Alfred Stieglitz Gallery in Chicago.
1918	Alfred Stieglitz offers her financial help, allowing her to paint for a year in New York. She begins to paint her flowers, still the most famous of her works today.

63. *Black Rock with Red*, 1971.
Oil on canvas,
76.2 x 66 cm.
Georgia O'Keeffe
Museum, Santa Fe.

1918-29	Her interest in oil-painting grows; she creates abstract works, especially landscapes and still-lifes.
1923	From 1923, and up to his death, Alfred Stieglitz works assiduously to promote O'Keeffe and her work, organizing annual exhibitions at the Anderson Gallery (from 1923 to 1925), at the Intimate Gallery (from 1925 to 1929) and at the American Place (from 1929 to 1946).
1924	Marriage of Georgia O'Keeffe and Alfred Stieglitz.
1925	They move into the Shelton Hotel in New York where they will live for twelve years. The apartment, situated on the thirtieth floor of the building, offers an unrestricted view of New York which Georgia paints numerous times.
1927	An exhibition is dedicated to her at the Brooklyn Museum.
1928	She sells six paintings representing lilies for a record price of $25,000 which brings her to the foreground of public attention. However, Georgia O'Keeffe feels the need again to travel to find new sources of inspiration for her painting.
1929	She leaves to go East, to Taos in New Mexico. This journey will change her life; she discovers a landscape of austere beauty and infinite space. She visits and paints the mountains and the deserts of the region as well as the historical Ranchos mission church in Taos. She returns every summer to "her country" up until the death of Stieglitz.
1930-31	She creates her first works representing skeletons.
1933	She is hospitalized in New York for nervous exhaustion.
1934	Georgia visits the Ghost Ranch for the first time and knows immediately that it is there that she wants to live.

64. Malcolm Varon,
*Georgia O'Keeffe at
the Age of Ninety at
Ghost Ranch*,
New Mexico, 1977.

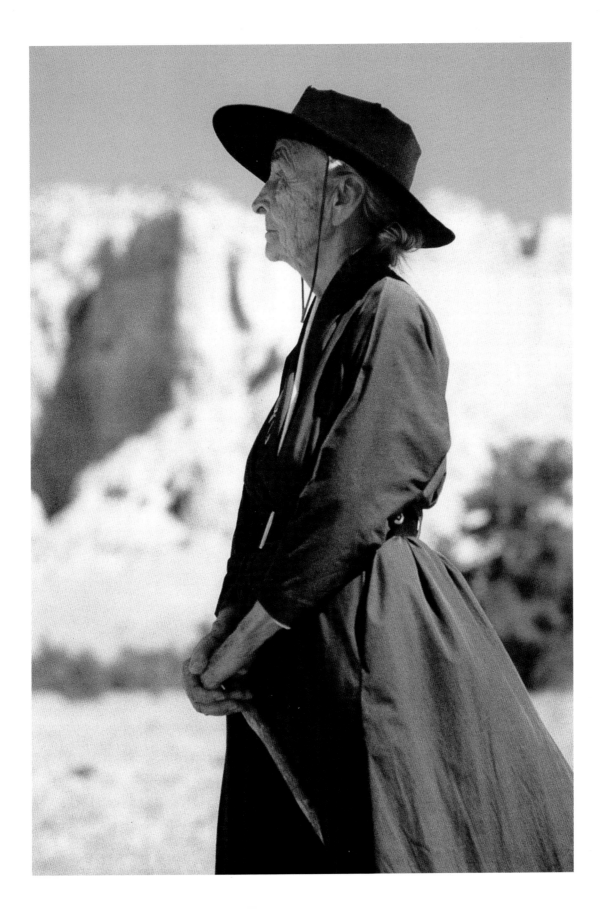

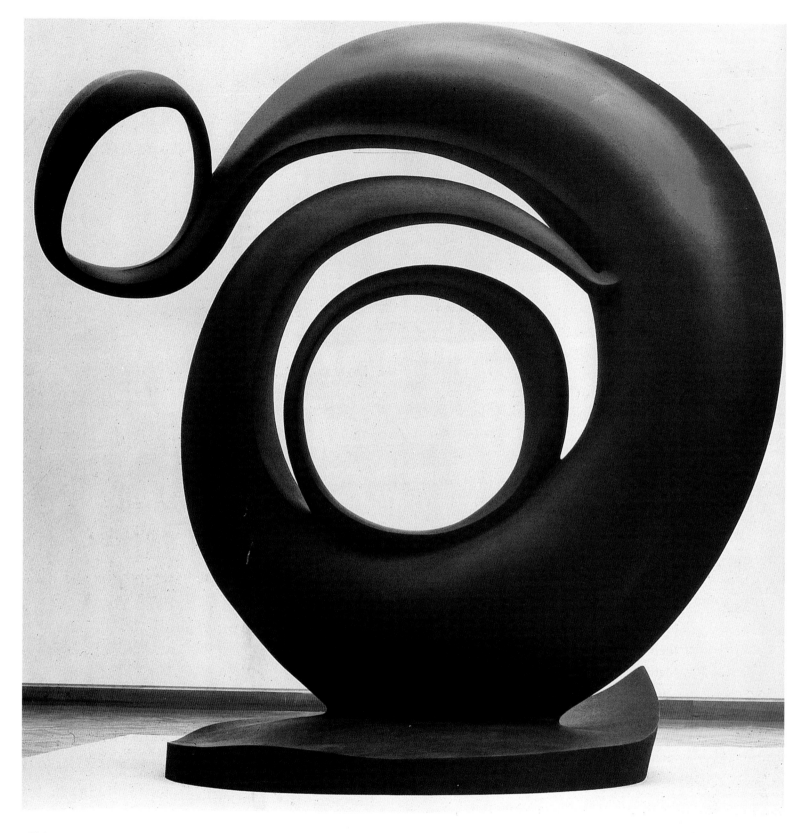

1943	Big exhibition of her works at the Art Institute of Chicago.
1945	She buys an abandoned farm property in Abiguiu village, near Ghost Ranch.
1946	An exhibition is dedicated to her at the Museum of Modern Art in New York; she is the first female artist to have the honour of an exhibition in this museum. Alfred Stieglitz dies July 13.
1949	She settles in Santa Fe, New Mexico, where she stays until her death.
1962	Georgia is elected amongst the 50 members of the American Academy of Arts and Letters – the highest national arts honour.
1951-63	She travels a lot, first in Mexico, then in Peru, India, Greece and Egypt, which will greatly influence her painting.
1971	At the age of 84 her eyesight deteriorates, and she is forced to stop painting in 1972.
1976	She writes a book about her art with the help of her friend Juan and allows the filming of a documentary at Ghost Ranch.
1986	Georgia O'Keeffe dies March 6, in Santa Fe, New Mexico, at the age of 98.
1987	A very important exhibition is dedicated to her for the centenary of her birth; it takes place first in the National Gallery of Art in Washington, D.C., then at the Art Institute of Chicago, the Dallas Museum of Art, the Metropolitan Museum of Art in New York and the Los Angeles County Museum of Art.
1989	Creation of the Georgia O'Keeffe Foundation in order to continue her memory and celebrate her work.

65. *Abstraction*, 1945, 1979-1980. Cast aluminium, 325.1 x 274 x 149.8 cm. Georgia O'Keeffe Museum, Santa Fe.

LIST OF ILLUSTRATIONS